MICHELANGELO: PAINTING

LUCIANO BELLOSI

THAMES AND HUDSON

Translated from the Italian by Geoffrey Webb

This edition © 1970 Thames and Hudson Ltd, London
Copyright © 1970 by Sansoni Editore, Firenze

Published in the United States in 1989 by Thames and Hudson Inc.,
500 Fifth Avenue, New York, New York 10110

Library of Congress Catalog Card Number 89-50744

Printed in Italy

Life and works

Michelangelo's prestige stands very high nowadays, as it did in his own age. He went out of favour for a time, especially in the seventeenth century, on account of a general preference for the works of Raphael, Correggio and Titian; but with the early Romantics in England, and the return to the Gothic, he made an impressive come-back. For Romanticism was on the look-out for the sort of genius that could be placed outside of time or place, or any kind of discipline. The truly great, of whatever period, would be able to recognize each other as equals. It is significant indeed that Blake could copy a figure from Michelangelo's *Crucifixion of St Peter* and describe it as one of the Gothic artists who built the cathedrals in what we call the Dark Ages.

Michelangelo began to be appreciated again because he represented the sublime in art, with a sense of beauty that ignored all conventional rules and proportions. And we can thank the Romantics for what is sometimes an undue emphasis on certain aspects of his works, the mysteriously expressive quality of what he leaves unfinished, for instance; his extremes of pathos, his frenzied struggles, and the sheer size of his subject-matter. Today we are less inclined to accept the notion of an artist existing outside his own age, and prefer instead to concentrate on the facts, and work out our interpretation in the light of what is historically true.

Michelangelo is certainly the most representative artist of the sixteenth century. He lived to a great age, and enjoyed great fame in his lifetime, and that not only in Italy. Titian, and Venetian painting generally, were very much influenced by his vision, and he is responsible in large measure for the development of Mannerism. He epitomizes the ideal put foward by Alberti of the artist as an intellectual. The painter and the sculptor were now raised to the same elevated level as the savant and the man of letters. They were at last free of the artisan status which

had obtained during the fourteenth, and to some extent fifteenth, centuries. In the sixteenth century, most intelligent people could see that artistic pursuits were not merely 'mechanical'. The major artists of this period were in fact on friendly terms with the intelligentsia, and rulers were glad to have them at their courts, even though the concept of the artist as courtier had not yet been clearly formulated.

Michelangelo made a considerable contribution here, and Vasari's admiration for him was in large part due to the fact that, as a person, he bore witness to the nobility of art. Instead of merely keeping to the terms of a commission entrusted to him, Michelangelo thought out his own projects, as for instance the tomb of Julius II or the ceiling of the Sistine chapel. No artist of the preceding period would have presumed to compete with the poets of his time in writing poetry, as Michelangelo did. His social standing allowed him to be a friend of Vittoria Colonna, the Marchesa of Pescara; and he was in a position to have medals made for himself, such as were minted for a man of the literary stature of Pietro Aretino.

Michelangelo's early training was rather different from that of other young artists. The normal process, which we find even with Leonardo and Raphael, was to be apprenticed to one master, and gradually to develop the teaching received with ideas of one's own. Michelangelo, who was born in 1475, entered the workshop of Domenico Ghirlandaio in 1488, and thus came under the influence of Masaccio. Ghirlandaio not only took from Masaccio ideas for sacred scenes dressed in contemporary fashion, but actually imitated certain of his designs. Michelangelo had the same awareness as his master of the heritage of the past: indeed he even went back as far as Giotto, as some of his most famous drawings demonstrate. He seems to have been intent on recovering the whole artistic tradition of Florence, and having recovered it, to impress his own personality upon it.

This attitude of mind was probably encouraged by his contacts, while still a youth, with the circle of Lorenzo the Magnificent. From 1489 to 1492 he lived in the Palazzo

Medici in Via Larga, which was frequented at that time by Poliziano, Marsilio Ficino, Pico della Mirandola, and Cristoforo Landino. Landino makes some useful remarks in his commentary on Dante about the Florentine artists of the fifteenth century. His judgment of Masaccio is well known – 'pure and unadorned'. It corresponds exactly with Michelangelo's opinion as expressed in the drawings he made of some of the figures in Masaccio's Brancacci chapel and of the *Consecration of Santa Maria del Carmine*. The rather stark figure with the great billowing cloak became the model for his figure of God the Father in the Creation of Eve in the Sistine chapel.

His interest in Giotto and Masaccio was not exclusive of course. He admired Filippo Lippi, Gentile da Fabriano, and Ghiberti, and his Madonna at Bruges clearly recalls a painting of Francesco Pesellino (now in Yale University Museum, illustration p. 6). None the less, it is the early, heroic phase of fifteenth-century art that inspired him most. The sheer humanity of Masaccio and Donatello made a great impact on their successors – Desiderio da Settignano, Pollaiolo, and the young Verrocchio – but these artists worked on a smaller scale. Their forms are refined, and full of nervous elegance. They tend to stylize and over-decorate. With Leonardo and Perugino there is an effort to achieve larger, more splendid figures, inspired by the classic mode. And with Fra Bartolomeo this purpose is fulfilled in thoroughly solid fashion in the fresco of the *Last Judgment*, which inspired Raphael's *Disputa*.

This tendency comes to its extreme fulfilment in Michelangelo. He was consciously developing the approach of Masaccio and Donatello, as we see clearly enough in his bas-relief, the *Madonna of the Staircase*, in the Casa Buonarroti, and in his studies of Masaccio's massive forms. The Madonna in question can be compared to Donatello's *Feast of Herod* in the Musée des Beaux-Arts at Lille. The proportions of Michelangelo's figures are enlarged to a monumental degree, and this new sense of proportion applied to the human figure will become the accepted mode from now on, and not only in the sphere of art. Lorenzo the Magnificent died in 1492, and in 1494 the

Medici were expelled from Florence. It was at this time that Michelangelo left Florence and went first to Venice and then to Bologna, where he could absorb the art and culture of Ferrara and admire especially the work of Ercole de' Roberti. In 1496, he eventually came to Rome and stayed there until 1501, concentrating on the nude and the antique.

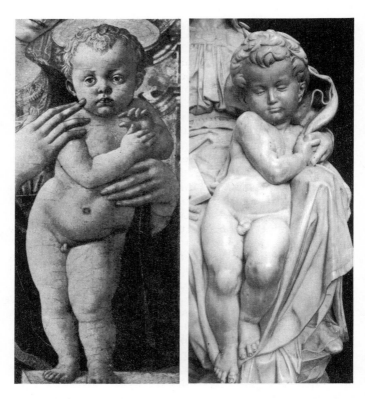

Pesellino, Madonna and Child. Detail. New Haven, Yale University Museum.

Michelangelo, Madonna and Child. Detail. Bruges, Notre Dame.

6

In the fifteenth century, the nude was a rather uncommon subject, and tended to be the mark of those artists who had an interest in antiquity. It was confined largely to mythological figures and statues of children. Donatello's *David* must have seemed exceptional in its time; Verrocchio's *David*, half a century later, was dressed in traditional biblical costume. The nude was most often treated in those small bronzes of pagan and mythological personages, and these were simply ornaments for the table or the escritoire. Donatello's followers in this genre were Bellano, Riccio, l'Antico and that same Bertoldo who was responsible for Michelangelo's training in sculpture. Michelangelo's relief, the *Battle of the Centaurs*, in the Casa Buonarroti has an interesting counterpart in Bertoldo's bronze relief in the Bargello.

Contemporary accounts tell us that Michelangelo set out early in his career to compete with the sculptors of antiquity, even that he was not averse to faking them. The *Bacchus* in the Bargello, which he sculpted for Jacopo Galli while he was in Rome in 1496-97, is at the same time his most archaizing work, and the very first nude of the sixteenth century. The nude obviously appeared to him to be the real secret of the antique. Antiquity only survived in its remains of statuary, and these remains became the very symbol of a superior type of humanity, outside of time, always strong and beautiful, as free from any laws of modesty, as from any concern with heat or cold, and beyond any sort of comparison with flesh-and-blood humanity.

Michelangelo's nudes are not real people. They are simply what the artist wants them to be beautiful, agile, muscular and graceful. His inspiration here was all of a piece with the rhetorical approach of Humanism, which was to be swept away in a hundred years' time by the scientific approach which, in painting, would have its counterpart in Caravaggio. Michelangelo's nudes, meanwhile, would be imitated to the point where they would become no more than academic exercises.

In the fifteenth century the nude was thoroughly stylized. Signorelli's figures seem to have been flayed; Pollaiuolo's

and Botticelli's are angular and full of tension. But Michelangelo's *Bacchus* is made in one free movement from the head to the feet. We can see how much he admired the way a man's body was made, in the breadth of the chest, the massive back, the fleshy fulness of the limbs, and the freedom of their articulation. By contrast, a nude of Pollaiuolo seems hard and affected, and it was precisely this affectation that would have been most frowned upon in the world of the sixteenth century. In his *The Courtier*, Baldassarre Castiglione sets out the rules for proper behaviour in society, and it is remarkable how often they tally with the aesthetic ideals of the artists living at the time — such ideals as grace, and an easy, unstudied manner.

The ideal of easy, flowing movement had already been introduced in such works as the unfinished *Adoration of the Magi* by Leonardo, in the Uffizi. All the different elements involved in this picture are gathered into a single idea, as into a whirlpool. With the greatest simplicity they are all involved in a perfect unity of composition. When Leonardo returned from Milan at the beginning of the century that was to signify a new epoch, he exhibited his cartoon of Saint Anne with the Madonna and child on her knee (the subject known as Sant'Anna Metterza). It was on show at the Annunziata, and here young Florentine artists could come and muse on this new method of composing a group.

Michelangelo, also recently returned to Florence, was among the first to take up the idea. Some of his drawings at this period are distinctly Leonardesque. There is in fact even a study for a Sant'Anna Metterza. And there is no doubt that the *Doni tondo* (*pls 1-4*), the first painting among his extant works that we can attribute with certainty to Michelangelo, was also the fruit of this experience.

He painted it between 1503 and 1504, for the marriage of Agnolo Doni and Maddalena Strozzi. Like the Sant'Anna Metterza of Leonardo, this Holy Family is a group of figures in a close-knit and studied composition. The movement of their inter-connecting arms forms a spiral that has something 'serpentine' about it, to use Michel-

angelo's word. Such a tightly-knit group makes us think, not so much of painting, as of the sculptured groups that will be produced throughout the course of the sixteenth century, groups like Giambologna's *Rape of the Sabine Women*. We know that Michelangelo thought that painting was the better if it aimed at the effect of relief. Here, in effect, everything is as highly finished and polished as it is in his marble *Pietà* in Saint Peter's. He uses a sharp, strident range of colours, with the iridescent qualities of sheet metal, the very colours, in fact, that Pontormo and Bronzino will take over. We have here a total negation of Leonardo's conception of painting, with its figures immersed in soft shadows.

There is something uneasy and restless here, but it is above all the strident colour scheme that places the painting outside the framework of serene classicism. To get his spiral effect, Michelangelo twists the figures and makes their bodies bend in a movement that is difficult and complicated. There is something unnatural about the Virgin, who looks more like a man than a woman. And there is something ambiguous about the nudes in the background, whose attitudes Tolnay has explained as follows. 'One of them is embracing his friend, while another seems to show that he is jealous... two others... are observing them.' It is this quality of unease, unnaturalness, eccentricity and ambiguity that particularly characterizes the Mannerist mentality.

The *Doni tondo* is undoubtedly the first painting which bears the mark of Mannerism. Look, for instance, at the standing nude on the right of the picture. The body is elastic and agile, the pose is studied, the gestures are unusual, the face is feminine and contrived. He is the forerunner of an infinite series of such figures. For Pontormo, Salviati, Parmigianino, Primaticcio, Bronzino, Pellegrino Tibaldi, Spranger, Cornelius of Haarlem, he will symbolize all that grace could mean for a Mannerist, not only in Italy but indeed all over Europe.

A theme familiar in Florence in the second half of the fifteenth century, was the tondo with the Holy Family, the infant Saint John, and angels. The group of naked

young men in the *Doni tondo* represents a new version of the angels. In every other case, too, Michelangelo gave his angels the form of young men, unclothed and without wings. This is the way we see them in the *Last Judgment*, where they hold aloft the instruments of the Passion, and again in *Saint Paul on the road to Damascus* in the Cappella Paolina, where they accompany Christ. Michelangelo was evidently not of a mind to tolerate the popular attributes in traditional religious iconography. Even his infant Saint John has been transformed from the usual, ascetic figure into a chubby, laughing Bacchus. As for the Holy Family themselves, they seem completely indifferent to the subject they are supposed to represent. Theirs is a perfectly straightforward demonstration of forms. A work like this could only be offered to a public that was sufficiently open-minded and sophisticated not to require an artist to produce a work that was merely a faithful representation of the subject laid down for him. The *Doni tondo* is something exceptional, something aristocratic. This is not to say that Michelangelo is indifferent to the religious content of the subject. He simply has his own ideas about the manner in which the subject shall be represented. When he was commissioned to paint the Battle of Cascina on a wall of the council chamber in the Palazzo Vecchio in 1504, he thought up something which does not in the least put us in mind of a battle. The fresco was never painted, but the cartoon for it was ready by the beginning of the year 1505, and it caused such admiration that it became, as Cellini said, a school for the whole world. All the young artists hurried to see it and make studies of it; it was eventually cut into pieces, and the pieces were lost. Our only complete copy is the one in the Leicester collection at Holkham Hall. This is a monochrome attributed to Bastiano (called Aristotele) da Sangallo. There are various prints of part of it, done by Raimondi and others, and there is a very fine drawing by a contemporary, possibly Daniele da Volterra, in the Uffizi (illustration p. 11). When we read the account of the battle by Villani, we can see that Michelangelo's group of nudes swarming on a river-bank is only justified by the fact that the Florentine

soldiery happened to be bathing in the Arno on the morning of the battle. It took place on 28 July 1364, and the day was very hot. When Manno Donati got to hear of it, he issued a reprimand. There is in fact no suggestion in Villani's account that the Florentine forces were taken by surprise by the enemy while they were bathing in the Arno. Michelangelo's *Battle of Cascina* is simply another excuse for the study of the nude, with a quite unimportant basis in fact and a story which he has himself invented. All this goes to show how, in the sixteenth century, an

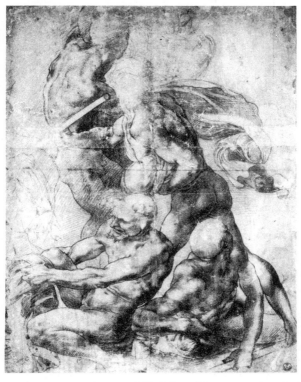

Contemporary copy of part of Michelangelo's cartoon for the Battle of Cascina. Florence, Uffizi.

artist of Michelangelo's calibre could impose his own ideas on his patrons, and so modify their requirements to his own way of thinking.

In this connection, the decorative programme for the ceiling of the Sistine Chapel presents Michelangelo's most sensational innovations. Before this commission, Pope Julius II had already entrusted to him the design for his own tomb. The original grandiose project was never carried out, but it was while he was working on it in Rome that the sculptor received an extraordinary confirmation of his ideas about the nude in movement with the discovery of the *Laocoön*. Evidence of the deep impression made on Michelangelo by the writhing figures of this Hellenistic group can be seen in the tomb of Julius, and in the paintings of the Sistine chapel.

Michelangelo accepted the commission for decorating the Sistine chapel ceiling (*pls 6-69*) on 10 May 1508, but right from the start he considered Pope Julius' plans altogether too simple. In a letter to Giovan Francesco Fattucci written in December 1523, he says 'The original design was for twelve apostles in the lunettes, and the other sections were to be filled with the usual kind of ornament. But when I had begun the work, I could see the result would be a poor thing... and so the pope gave me a new commission, this time to do what I wanted.'

It was something unheard of for a patron, and the pope at that, to allow his own plans to be completely changed by an artist. In this case, moreover, the change of plan meant that the work would have an entirely different meaning from the original one. The artist was to be completely responsible for the iconographic scheme. Michelangelo's intelligence was to be deferred to in a way that had never been conceded to any other artist, not even to a Giotto, a Masaccio, or a Piero della Francesca.

At this point, Michelangelo's intolerance of simplicity becomes very clear. Confronted by the vast area he was to decorate, he could not but succumb to the temptation to create something that no one else could equal. It would be something gigantic, full of complexity and difficulty. It would incidentally be a compensation for having to

abandon the project for Julius' tomb, and Michelangelo may well have used this disappointment to his own advantage when persuading the pope to accept his new and colossal design for the Sistine ceiling.

Michelangelo had a passion for being exceptional, and at the same time, like Leonardo, he had something of the dilettante approach which was so important in Alberti's ideal of the artist as an intellectual.

Since he was not very familiar with the technique of fresco, he needed the help of several Florentine painters, as well as the advice of Giuliano da Sangallo in the matter of counter-acting the mould which resulted from the extreme dampness of the lime. But his ambition to produce a work that would be absolutely exceptional, positively legendary, made it impossible for him to work with others, and in the end he did the whole thing himself. This was something quite unprecedented. Not only was the work so vast in scale, but it was a fact that no artist hitherto had ever undertaken a whole cycle of frescoes without an efficient group of helpers. Michelangelo helped to create his own legend, complaining of the enormous difficulties of the enterprise. In his sonnet *On the painting of the Sistine chapel*, he describes how he has grown a goitre, and all the other discomforts involved in painting a ceiling, how he hates the place, and despairs of being a painter at all.

One can quite see why he found Pope Julius' original design with twelve apostles a 'poor thing', when one contemplates this immense stretch of ceiling filled with such a throng of vital and tormented human bodies. To quote Briganti: 'The whole work proclaims a superior man's conviction that he is incapable of sharing the thoughts and feeling of common men.' Michelangelo has created a whole world of nudes, each one exceptional in itself, and all of them tense and preoccupied, essentially unrelated to the everyday world.

Instead of offering us a vision of the world and of nature, a universal vision, as Leonardo would say, he gives an exhibition of human bodies. The human form in all its different functions occupies every part, like a single element,

even an obsession. The whole space is composed of bodies and architectural structure. It is as exclusive and as eccentric as it could possibly be, but its originality is so overpowering that one can quite understand how the sixteenth century fell under its spell. Raphael's Sibyls in Santa Maria della Pace, Parmigianino's ceiling at S. Maria della Steccata, the gallery at Fontainebleau, the Sala Paolina in Castel Sant' Angelo, Pontormo's *Visitation* in the Annunziata at Florence, Pellegrino Tibaldi's ceiling in the Palazzo Poggi in Bologna, all these derive from the ceiling of the Sistine chapel.

The extraordinary thing about Michelangelo's design is that it is elaborated and articulated as a single unit. The groups are so framed in a system of cornices that they give the effect of enormous plaques and cameos. Yet not a single one of them is meant to stand on its own. Each one is perfectly integrated into the unity of the whole.

Paradoxical though it may seem, one of the most important factors in this unity and continuity is the difference in scale that Michelangelo uses among his figures. We are so used to seeing isolated series of reproductions — a set of sibyls, a set of prophets, a set of Ignudi — that we may fail to realize the difference between their respective proportions. Even in the Genesis group the scale of the figures varies. In the Creation of Adam they are large, in the Flood they are smaller than the Ignudi that accompany them while Adam is in fact larger than the Ignudo beside him. But in comparison with the Ignudi, the prophets and sibyls are colossal — nearly four times the size of the figures in the adjacent triangles, and nearly three times larger than the bronze-coloured nudes alongside them. Again there is a difference of scale in the episodes in the four corners of the ceiling.

In effect, the rules of perspective are completely contradicted. All the respect which the fifteenth century had for proportion seems to have disappeared. We know, of course, that Michelangelo had his own ideas about proportion. Vasari tells us that he made his figures nine, ten, or even twelve heads long. The effect he sought was that, when they were seen all together there should be a certain

harmony, a 'grace' in the ensemble which nature alone could not give. He said that the measurements in question should be in the eye, not in the hand. To judge proportion optically is tantamount to bypassing perspective. Michelangelo has rejected calculation and mathematically constructed perspective of the type elaborated by Alberti and others. The practical approach, so highly praised by Vasari, and so disparaged by later authors, acquires a new value. And it is this new and relaxed concept of proportion that, for all its artifice and unnaturalness, allows groups of differing proportions to merge into each other, and so be linked together as a unit.

As we have seen, Michelangelo had no interest in the historic reality of the twelve apostles. He found the subject 'a poor thing'. He preferred the kind of humanity, completely removed from the everyday world, we find in the Old Testament, especially the book of Genesis. He wanted to depict the protagonists of humanity, and the events that were to prove so fatal for mankind, and to relate them to ancient prophecies and to the idea of a divine origin at the beginning of time.

A great deal of what has been written on the exact interpretation of the subjects Michelangelo chose to represent is conjecture; it tends to confirm the suspicion that the prime considerations were representational rather than symbolic. This does not mean that our approach is meant to be exclusively visual but certainly Michelangelo imposed his own sense of form on any subject-matter whatsoever.

The Sistine ceiling summarizes the story of the pre-Christian world. It begins with five pictures of Creation. The other four deal with original sin and its punishment in the expulsion of Adam and Eve from the garden of Eden, the Sacrifice of Cain and Abel [1], the Flood, and the Drunkenness of Noah (i.e. the sin and punishment of Ham). The series

[1] It is difficult to believe that this scene, coming as it does between the Original Sin and the Flood, can in fact represent the Sacrifice of Noah, as it is commonly held. In fact the Sacrifice of Noah came after, and as a consequence of, the Flood. Moreover, the story of

of sins and punishments, taken mainly from the Kings continues in the bronze medallions supported by the Ignudi. The significance of the Ignudi on the ceiling has been much debated. They present the same problem as those we have already considered in the *Doni tondo*, and they are probably angels. Angels bearing coats of arms are common on fifteenth-century tombs, and these nudes may be Michelangelo's version of a traditional motif. Here, on the Sistine ceiling, they are holding festoons of oak leaves and acorns which, incidentally, figure in the arms of the della Rovere family to which Pope Julius II belonged. They are placed so as to reveal every possible aspect of masculine beauty, strength and elegance, offering almost infinite variations of one theme.

Michelangelo has painted a great cornice to act as a mount for this part of the ceiling, and beneath it sit the colossal figures of seven prophets and five sibyls, all of whom, in

Cain and Abel, unlike the Sacrifice of Noah, is very much involved in the theme of sin, and it happens to be the chief episode in Genesis between the Original Sin and the Flood. Another important point is that there are four figures in this scene, whereas Noah's sons were definitely three, and their names are given. The number of Adam and Eve's children is left vague. In the first edition of Vasari's Lives, this scene is called the Sacrifice of Noah, but in the life of Michelangelo written by Condivi, his young friend and disciple, it is called the story of Cain and Abel. In his second edition, Vasari corrected the title accordingly, even though he had no liking for Condivi. Thus there is no doubt that those nearest to Michelangelo understood the picture to represent Cain and Abel. The significance of the scene would then be that the whole family of Adam and Eve are taking part in the sacrifice that Abel performs in offering the first-born of his flock. Adam, as an old man, is showing them that the sacrifice has been accepted by God. Abel, assisted by two brothers, is slaughtering goats, and he offers the fat part of the meat, which is mentioned in the text, to his wife. Cain is moving off to the right with a bundle of fire wood. His envy is apparent by the expression on his face. His wife is taking fire from Abel's altar in order to light the wood for Cain. The only thing needing explanation is the elephant which has strayed into Abel's flock. Michelangelo's aim here is obviously to convey the idea of a sacrifice performed in the manner of some far off time. He is not too much concerned with following the story literally, any more than he is in his *Battle of Cascina*, or when he shows Haman crucified instead of hanged.

one way or another, predicted the coming of Christ. It was probably more for reasons of variety than of iconography that he alternated these five legendary women with the seven biblical characters. The large figures are accompanied by smaller ones, who resemble the angel traditionally accompanying the evangelist Matthew. These too are probably angels. On the pilasters beside the thrones on which the prophets and sibyls sit, are groups of putti acting as caryatids.

Between the sibyls, in the triangles on either side of the ram's head ornament, are placed matched pairs of bronze-coloured nudes. They are given capricious attitudes, and a certain erotic, perhaps even diabolical character.

At the four corners of the ceiling are placed the four miraculous interventions of God for the salvation of Israel: the Brazen Serpent, Queen Esther and the punishment of Haman, Judith and Holofernes, and David and Goliath.

The triangular spandrels and the lunettes round the windows are dedicated to the ancestors of Christ as enumerated by Saint Matthew. They are chosen for their ability to be made into groups, Holy Families, as it were, with a certain variety among them. They are purposely kept in shadow so as to contrast with the explosion of movement that breaks out in the higher part of the ceiling which gets the maximum play of light.

The whole enormous enterprise was approached in inverse sequence to the way in which it is told in the Bible, and we in turn must approach it in Michelangelo's way. There is a definite crescendo as we move towards the story of creation. In the beginning, everything is still and symmetrical. We are given the maximum of variety and movement at the end, with the foreshortened figure of Jonah, the Eternal Father separating light from darkness, the punishment of Haman, and most of all with the Brazen Serpent. Here the excited sense of movement clearly recalls the *Laocoön* [1].

One has the impression that Michelangelo was incapable of conceiving a form that was not in movement. Rarely

[1] For individual figures on the ceiling, see captions to plates.

does one of his figures have its feet pointing in the direction to which the eye is looking, unless it happens to have turned round completely. Those few of his figures which do not move – some of Christ's ancestors, and God the Father creating Eve, for instance – have a very disturbing quality about their very fixity.

Michelangelo intended to write a work 'On all the manners of human movement', as a reproof to Dürer, who considered only the measure of bodies, and their variety, with the result that his figures looked 'as stiff as posts', as Condivi put it. Michelangelo had no time for the simplicity of traditional form as the fifteenth century understood it.

When the Sistine ceiling was finished, it was immediately recognized as a work of major importance to the world of art. It was partially uncovered in 1510, and completely visible by the autumn of 1512. It was such a leap forward from the art of the fifteenth century, there could be no doubt that a new epoch had arrived. Its grand manner and elevated style, with every form strengthened and magnified, made a tremendous impact. Raphael, who has too often been considered to occupy the opposite pole to Michelangelo, was among the first to benefit from the new grandeur. We have only to look at certain of Raphael's figures such as the gigantic Heraclitus in the *School of Athens*, the philosopher with upraised arm and the figure standing by Saint Gregory with his back to us in the *Disputa*, to realize that only the Sistine ceiling could have inspired them.

The skill, and the apparent ease with which Michelangelo had magnified his style, were totally bewildering. He was so completely in control of what he was doing. It seemed impossible for him to make a mistake, though he had obviously gone to great trouble to devise the most difficult effects. His self-confidence was so evident in this master-piece, that every other artist was cowed, even 'terrorized' as Vasari says. It was almost unbelievable to think, for instance, that the prophet Jonah was actually painted on a piece of masonry that jutted out from the wall. Only a painter of genius could, in that circumstance, make the prophet really look as if he were bending backwards.

The Sistine ceiling epitomizes a new stage in the history of art, something more ingenious, more contrived than anything that had preceded it. Michelangelo simply could not accept the existing canons of religious art, any more than he could accept the world about him at its familiar and agreeable face value. He had to insist on complicating every form into something unusual, enigmatic, even grotesque. He loved what was difficult and forced and artificial. In his ceiling we find the agitation and uneasiness, the sophisticated elegance, the beauty fraught with spirit and movement, the total defiance of proportion, all, in fact, that characterizes the tension and extravagance of Mannerism.

The two Medici popes, Leo X (1513-21) and Clement VII (1523-34) preferred to keep Michelangelo well away from Rome and from the tomb of Julius II, so that he could work on the Medici church of San Lorenzo in Florence. It was during this period, while he was planning the tombs in the New Sacristy, that the sack of Rome occurred (1527), and when Florence was besieged shortly after, he helped in fortifying the city, which finally came back into Medici hands in 1530. While the siege was still on, he managed to get away for a while to look after his own property. He incurred the displeasure of Alessandro de Medici, who was murdered by Lorenzino in 1537. This event he commemorated in his bust of Brutus, now in the Bargello.

During this period in Florence he produced some sketches for paintings, and gave his friend Sebastiano del Piombo some ideas for his frescoes in San Pietro in Montorio in Rome, and his *Resurrection of Lazarus* in the National Gallery. Michelangelo also painted a Leda in tempera, using a pose rather similar to that of his figure of Night in the Medici chapel. This has been lost, but there are some copies of it, and an engraving by Beatrizet. He also did a cartoon for Christ and the Magdalen, which was used by Pontormo, Bronzino and Battista Franco. (The Pontormo is now in a private collection in Milan, and the two others are in the Casa Buonarroti in Florence.) Another of Michelangelo's cartoons, the one showing Venus and

Cupid, inspired several paintings. The one attributed to Pontormo is to be seen at the Casa Buonarroti. Both the anatomy and attitude of the Venus are extraordinary; she seems to have haunted Pontormo in his old age, as we can judge by his later drawings, and by Vasari's remarks about the frescoes, now lost, which he did for Careggi and San Lorenzo.

It was perhaps for a lunette in the New Sacristy, Tolnay suggests, that Michelangelo worked out some ideas for the Resurrection. Various drawings have survived, including one in the British Museum (*pl. 70*) where the naked figures move as elegantly as dancers. His hovering figure of the risen Christ may well be the one that exercised such an influence on the visionaries of early Romanticism in England, such as Fuseli and Blake.

It was in the year 1532, while he was staying in Rome, that Michelangelo got to know Tommaso de' Cavalieri, who must have been the most outstandingly beautiful of all the young men who gravitated round him during his long life. Even to his contemporaries, his friendships seemed rather strange. Aretino liked to point out maliciously that he was very generous toward certain young men, and Condivi felt called upon to defend him against such allegations. Michelangelo's poems and letters confirm the suspicions that were voiced at the time, and there is no doubt that subtle homosexual overtones become more apparent, both in the lives and the works of many artists in the sixteenth century.

Michelangelo presented some of his drawings to Cavalieri, including mythological subjects of an erotic nature, like the Rape of Ganymede, and the giant Tityus attacked by a vulture. It is possible that the drawing of a young man surrounded by the seven capital sins was also a present to Cavalieri. Sensuality is represented here by a range of sexual deviation that verges on the pornographic.

In September 1534 Michelangelo settled down finally in Rome, and he was to stay there for the rest of his life, despite flattering invitations from Cosimo I Medici at Florence. The new pope, a Farnese who took the name of Paul III, confirmed the commission that Clement VII

had already given him for a large fresco of the Last Judgment over the altar of the Sistine chapel (*pls 71-76*). In order to do this, Michelangelo had to remove the fifteenth-century frescoes already on the wall, together with two lunettes showing ancestors of Christ, which he had himself painted forty years previously. He also had the wall built out toward the ceiling, so as to avoid the dust gathering on the surface of the new fresco. Scaffolding began to be erected on 16 April 1535, and the work was officially unveiled on 31 October 1541.

Michelangelo was by now in his sixties. Everyone acknowledged his 'terrible' mastery in treating the human form, and virtually all the art of Europe was following the line that he had traced out for himself. But now a profound change occurred in his style. It was as if he needed to mortify, even punish himself in his art. His bodies lose their elegance and their elasticity. They become heavier and broader. Muscles thicken into great knots of flesh. The head becomes smaller, a mere appendage to the disproportionately wide torso. It was as if Michelangelo felt that the really expressive human qualities were to be found in the body rather than the head. The effect of his foreshortenings and contortions, with such an emphasis on joints and muscles, is to create a mass of sheer physical being that seems to move like some highly powered automaton.

These heavy bodies, broadened to the point at which they look pathetic or grotesque, are flying about in an empty space, without the help of wings, and with no flat surface to rest upon. Here we have the total rejection of that scientific, reasonable approach that characterized the early Renaissance. Physical law is passed over, and all certainty seems to have collapsed. We are a world removed here from the carefully thought out measurements of Brunelleschi and Masaccio, and the exquisite theorems of Piero della Francesca.

Having freed himself from all the rules of proportion, Michelangelo achieves the most extraordinary effects. The group of saints on Saint Bartholomew's right are placed further forward than Saint Peter on his cloud, yet they

are about half his size. This sort of treatment is all the more puzzling for the fact that there are no architectural elements used to separate the various groups, as there are in the ceiling. The figures in the Last Judgment vary in height from 250 to 155 centimetres.

Michelangelo has almost completely jettisoned the ideal of *grazia*. This fresco creates an atmosphere of unrelieved gloom. Eyes, wide-open and full of terror, are the only expressive motif in the composition (illustration p. 22). All hope seems to have disappeared, not only for the damned, but for the elect as well. Once again, Michelangelo imposes his own ideas on the narrative, just as he does on the figure structure. Giotto, Angelico, Fra Bartolomeo, all had treated the subject, but had never hinted at anything like this sense of general despair. Here, in the Sistine chapel, one feels that even saints and angels will have to spend their eternity in struggling to hold their position secure. Even the angels holding the instruments of the Passion look as if they were engaged in some furious combat.

The most powerful of all these figures, standing like a Hercules who has conquered everything, is Christ himself,

Michelangelo, the Last Judgment. Detail.

flinging down his curse with terrific force. Gathered round his vast torso, a closely knit group forms a sort of halo for him. On either side of him falls a stream of humanity, where entangled bodies clutch at each other, embrace, or desperately stretch out their hands. Here we find forms of great beauty and power, which are all the more touching on account of the general feeling that there is no consolation, only despair.

At the very top of the composition are the angels with their books and trumpets, gigantic figures with abnormally broadened torsos. On their right hand, the heavy bodies of the elect struggle towards the heights, while the fallen angels and devils go down on their left, violently attacking each other.

At the bottom of the picture, we are in a region of absolute horror. On the left, the heavy forms of the dead are rising from the ground, surrounded by skeletons and grinning skulls (*pl. 75-76*). The vast bulk of their flesh and muscle makes them look almost too weary to move. And on the other side a dark mass of figures pours out of Charon's boat, their hideous faces like masks used in decoration.

For the taste of today, there is much here of course that savours of rhetoric, of artificiality, of an academic approach to bodily structure, yet at the same time we must admit that it is the perfect vehicle for the gloom, the bitter sadness that Michelangelo wanted to convey. All light, all grace, all warmth, have been denied to this race of punished giants. Their gestures are grotesque and terrifying, everything is in the dark, fraught with fear. Every single face expresses the same endless grief.

If we are in the habit of thinking of the Renaissance world as something perfectly balanced, as a serenely civilized world basking in classical antiquity, we may well ask ourselves how Michelangelo's vision of total desolation fits into it. The fact is, however, that during the fifteenth and sixteenth centuries, the perfect balance that we think of as typifying the Renaissance was quite rare, at least in the sphere of art. It occurs at certain times, and is manifest in the works of artists like Nanni di Banco, Masaccio, Luca

della Robbia, Giovanni Bellini, Raphael, and the young Titian. As far as Michelangelo is concerned, we have already noted how a sense of disquiet occurs quite early in his work, casting strange shadows on things which are quite unquestionably beautiful. During the course of the sixteenth century, civilized values in Italy were very much under fire. First came the breakdown of the Reformation, then the sack of Rome, revealing how pathetically vulnerable the papal capital was, even at the height of its glory. These two factors left their marks on Rome, and explain why the Roman mentality underwent such a change as it embarked upon a Counter Reformation, and entrenched itself once more in austerely medieval attitudes.

Michelangelo's personality was of the sort to be deeply impressed by all this. He had never forgotten the sermons of Savonarola, and now that he had become a friend of Vittoria Colonna, there were to be no more tributes of beautiful mythological subjects for Tommaso dei Cavalieri. Now it was the Crucifixion and the Pietà that he thought most about, and his sonnets take on a note of severity, as he comes into closer contact with the supporters of the Counter Reformation. His *Last Judgment* could only have been painted at a time of intense disenchantment and contrition. And it is from Michelangelo that so much Counter Reformation art derives its emphasis 'on cemetery and corpse', as Zeri observes.

For Vittoria Colonna, Michelangelo drew a Pietà, which was inscribed 'No one knows how much blood this cost'. And Condivi points out that in one of the Crucifixions he did for her, the cross 'was similar to the one carried in procession during the plague of 1348'. Some other drawings he did were later copied by Condivi. There is a poor treatment of the Holy Family in the Casa Buonarroti, of which we still have Michelangelo's magnificent cartoon. There are also two treatments of the Annunciation by Marcello Venusti, based on Michelangelo's drawings, and also a Christ in the Temple, and a Christ in the Garden which is oppressively gloomy and severe (illustration p. 25). Between 1542 and 1550, after various interruptions due to illness, Michelangelo painted the two frescoes in the

24

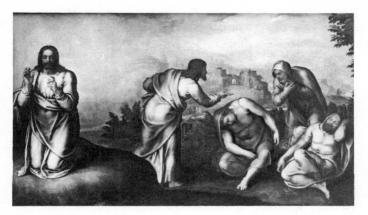

After Michelangelo, Christ in the Garden. Vienna, Gemäldegalerie.

Pauline chapel in the Vatican, showing the Conversion of Saint Paul and the Crucifixion of Saint Peter (*pl. 77-78*). In the rather constrained space at his disposal, there was no possibility of displaying anything like the originality that we find in his *Last Judgment*. As a result, these two frescoes have been dismissed as minor works, and Mannerist at that. However, we have already observed the importance of Mannerist tendencies even as early as the *Doni tondo*. In these frescoes the arrangement of movement and *contrapposto* has become simpler, more relaxed, especially in the *Crucifixion of Saint Peter*. The enormous size of the figures tends to make their gestures slow and massive. We find here the familiar obsession with exaggerated joints and muscles, but there is less tension now than there was in the *Last Judgment*. Even though these frescoes are in a poor condition, it is clear enough that, by this period, he is aiming at vague and shadowy effects.

In the *Conversion of Saint Paul* he returns again to the theme of fear. And in the *Crucifixion of Saint Peter* there is an atmosphere of suspense among the groups of Christians speaking softly among themselves, and making

signs to each other not to make any noise that might betray them. At the top of this fresco, at the right, a group of gigantic figures moves forward with slow gestures and sorrowful expressions. These are the simplest figures that Michelangelo ever achieved in painting.

Despite the fact that the painter seems to be punishing himself toward the end of his life for having indulged such a passion for energy and vitality, he refuses to conform to the new bigotry of the Counter Reformation. There are fewer nudes, but still no part of the human figure is suffered to be hidden. Saint Peter is completely naked, as also are the angels who throw Paul to the ground. Fortunately it is still possible to see what the frescoes looked like before their limbs were painted over with clothes, in some contemporary engravings by Beatrizet, Michele Lucchese, and Giovan Battista de' Cavalieri. There is a final touch of the provocative in the group of angels, with one of them stretched out in the traditional pose of Hermaphroditus.

The last three years of Michelangelo's life were devoted to his sculptures of the Pietà, to architecture, and to the drawing of exclusively religious subjects. At this stage, he seemed almost to be repressing his own ability to draw. The hand is uncertain, the line constantly reworked with a length of soft pencil. The figures are as simple and as heavy-looking as blocks of stone, enlivened only by the thick hatching which constantly repeats the outline, and yet barely suggests the form.

It is the theme of the Crucifixion that seems to mean most to him at this stage. There are various sketches of the subject, pared down to the barest essentials, with only three figures. In one treatment, the arms of Christ are raised almost vertically (*pl. 80*). The effect is impressive, even for those who do not take easily to any suggestion of the mystical. Another treatment spreads the arms out horizontally. The body bends slightly to one side, and the head hangs down (illustration p. 27). One has the impression of looking at a humiliated giant. The figures on either side of the cross are seen in a *chiaroscuro* that acts like an opaque glass between them and us. Their attitude is

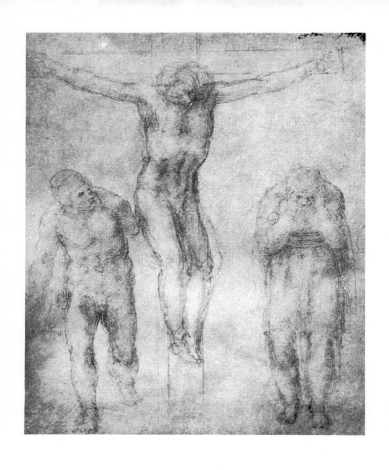

Michelangelo, Crucifixion. Drawing. London, British Museum.

crushed, and worn down. Even though he is not far from the grave himself, Michelangelo still insists on caressing his nudes with shadow, but now the body is something sadly hollow. And with these figures, so touching in their simplicity, so full of sorrow, we come to the end of Michelangelo's career.

In him the art of the sixteenth century is epitomized, even though he was not a revolutionary like Giotto, Masaccio or Caravaggio. His work is none the less characterized by its unfailing originality. His contribution to art was of inestimable importance. Art had already become something aristocratic, and the ideals of art were already similar to those laid down in *The Courtier*. But when Michelangelo died in 1564, an artist had become someone who was in every sense his own master, and a member of a new nobility.

Michelangelo and the critics

A vast amount has been written about Michelangelo, and it would be very valuable if someone ever had the patience to read through it all. It is basically a question of sorting out what is mere rhetoric, inspired by infatuation with the subject, and what is of interest in relation to the cultural and artistic movements of the various periods in which the books were written.

The excellent work of E. Steinmann and R. Wittkower, *Michelangelo Bibliographie, 1510-1926*, Leipzig 1927, deals only with the titles of the 2096 books produced up to 1926. This work (which has the disadvantage of being arranged alphabetically instead of chronologically) was continued by H. W. Schmidt in an appendix to E. Steinmann's *Michelangelo im Spiegel seiner Zeit*, Leipzig 1930, and by P. Cherubelli in his *Supplemento alla bibliografia michelangiolesca 1931-1942*, pp. 270-304 of 'Centenario del Giudizio', Florence 1942. More recently P. Barocchi has continued the bibliography in *Giorgio Vasari, La vita di Michelangelo*, Milan-Naples 1962, vol. I, pp. 338-76. Also P. Meller in *Aggiornamenti bibliografici*, vol. II of *Michelangelo artista, pensatore, scrittore*, pp. 597-605, Novara 1965.

The most important biographies of Michelangelo are undoubtedly those of Vasari and Condivi. They were written while the artist was still living, and the authors were both on friendly terms with him. Vasari, *Le vite*, Florence 1550, 2nd edition Florence 1568. This edition has been edited by P. Barocchi, already mentioned. Condivi, *Vita di Michelangelo Buonarroti*, Rome 1553. More recently we have the extensive researches of Thode in his *Michelangelo - Kritische Untersuchungen über seine Werke*, Berlin 1908-13, also *Michelangelo und das Ende der Renaissance*, Berlin 1912-20. Karl Frey has also produced two books: *Michelangelo Buonarroti, sein Leben und seine Werke*, Berlin 1907, and *Die Handzeichnungen Michelangelo Buonarrotis*, Berlin 1909. Finally we have the five

volumes of Charles de Tolnay's *Michelangelo*, Princeton 1947-60.

The neo-platonic interpretation of Michelangelo's works, pioneered principally by Panofsky in *Idea*, Leipzig-Berlin 1924, cannot be said to have brought about any concrete results. Neo-Platonism was common currency in the culture of the Renaissance. One therefore questions how it can be considered specifically valid for understanding Michelangelo's mind. Cf. E. Garin in the above mentioned miscellany, *Michelangelo artista, pensatore, scrittore*.

As a result of the recent reassessment of Mannerism, Michelangelo has been put forward as prime mover by two authors: R. Longhi in *Ampliamenti dell'Officina ferrarese*, Florence 1940, *Arte italiana e arte tedesca*, Florence 1941, and in various articles in *Paragone*, nos. 13 (1951), 43 (1953), and 101 (1958). G. Briganti, *Il Manierismo e Pellegrino Tibaldi*, Rome 1945, and *La Maniera Italiana*, Rome 1961. It is to these two authors that the present writer is principally indebted in this text.

On the subject of Michelangelo's drawings, there is first of all the already mentioned work of Frey, *Die Handzeichnungen Michelangelos*, and also a more recent work, L. Dussler's, *Die Handzeichnungen des Michelangelo*, Berlin 1959. This book, however, does not by any means solve all the problems involved.

For the Sistine chapel, Steinmann's *Die Sixtinische Kapelle*, Munich 1901-05, is still the standard work. There is also R. Salvini's, *La Cappella Sistina in Vaticano*, Milan 1965.

Notes on the plates

1-4 Holy Family (The Doni tondo). Diameter 120 cm. Florence, Uffizi. This is Michelangelo's extremely personal version of a subject that was very popular in Florence in the second half of the fifteenth century, a round picture showing the Holy Family with angels and Saint John the Baptist as a child. It was painted between 1503 and 1504 for the marriage of Agnolo Doni and Maddalena Strozzi, whose portraits were painted about this time by Raphael. The figures are articulated and connected together within a complex knot and their movements create a spiral effect. The painter shows complete mastery of the body in its most difficult positions, especially in foreshortening. He shuns simplicity in his figures. An important influence in the *Doni tondo* is that of Leonardo, who was the first painter to inter-relate a group of figures in this close fashion. Leonardo's influence is evident also in minor details, such as the elaborate hairstyle of the nude figure to the left in the background. Of the three nudes on the right, whose attitudes would seem to suggest love and jealousy, the one in *pl. 4* is quite the most ambiguous in the whole scene. The pose is curiously contrived and feminine, and of itself is almost a manifesto of what Mannerism means: a departure from the classic approach to the natural.

5 Male nude. Pen drawing. London, British Museum, No. 1887-5-2-117 r. This figure of a young man running is generally considered to be one of the studies for the *Battle of Cascina*. Michelangelo's drawings often take on the look of his unfinished sculptures, the torso from shoulder to thigh being his chief point of interest.

6 The ceiling of the Sistine chapel. Rome, Vatican. This enormous and complicated fresco was begun in 1508, partially uncovered in 1510, and completed in 1512. In order to make room for the Last Judgment, Michelangelo had to remove two lunettes showing the ancestors of Christ. During the sixteenth century a partial restoration of portions of the ceiling was carried out by Anselmo Anselmi, in particular the sacrifice of Cain and Abel. In 1700 part of the plaster fell from the sky in the Flood scene, and from the Ignudo adjacent to it.

7 The Drunkenness of Noah. Sistine chapel. Vatican. This scene, together with the Flood, the Sacrifice of Cain and Abel, and all the adjacent figures, is the earliest part of Michelangelo's work on the ceiling. It will be noticed that both colour and *chiaroscuro* still have the metallic qualities of the *Doni tondo*, and the Ignudi of this period are still stable and symmetrical.

8 Ignudo. Beside the Drunkenness of Noah. Sistine chapel. Vatican. The Ignudi which occupy the space at the four corners of each of the smaller scenes, are probably angels, which Michelangelo normally represents as young men, nude and wingless. Here they are used for holding the garland of oak leaves, which was the heraldic device of Pope Julius II's family, the della Rovere.

9 The Death of Joram. Sistine chapel. Vatican. This story is depicted in a medallion alongside the Drunkenness of Noah. Most of the subjects shown in the medallions come from Kings, and they take over the theme of sin and punishment from Genesis. Joram, like his father Ahab, 'did what was evil in the sight of the Lord', and Jehu, who was chosen by God to destroy the house of Ahab, killed Joram when he was trying to escape in his chariot. (II Kings, IX).

10 Ignudo. Beside the Drunkenness of Noah. Sistine chapel. Vatican. One has the impression that these Ignudi perform the same function as the so-called 'slaves' and 'prisoners' in the original project for the tomb of Julius II. They are figures whose primary function is to reveal the beauty of the human body, which for Michelangelo was an image of the divine beauty, but who have no direct connection with the scenes beside them.

11-12 The Flood, and two Ignudi. Sistine chapel. Vatican. It is surprising that Michelangelo should underplay the tragic element in this episode, and concentrate on the woman with the two children in the foreground, and the sombre procession of people struggling up the bank. The drama appears more in the frenzied group in the background. The two Ignudi, very different in proportion from the figures in the picture, are noticeably pressed close to it so as to link it with the surrounding subject-matter.

13 The Flood. Detail. Sistine chapel. Vatican. The two figures on the right were possibly painted without any cartoon. They are done with unusual freedom, particularly the curious young man in red with dripping wet hair, The woman in a cloak, drying her tears, is a magnificent figure of ideal beauty. She is of the type that Pontormo was to use for his pious women in the Passion of Christ in the Certosa at Florence.

14 Isaiah. Sistine chapel. Vatican. The prophets and sibyls are the biggest figures on the ceiling, and their monumental size emphasizes a certain rhetorical quality.

15 Ancestors of Christ. Detail. Sistine chapel. Vatican. The ancestors occupy the triangular spandrels and the lunettes. This particular group is in the spandrel beside the Flood. The ancestors are named in the gospel of Saint Matthew, but little is known about most of them. It is evident that Michelangelo liked to exercise

his intelligence about these mysterious people, most of whom are painted in attitudes of unrelieved sadness.

16 Ancestors of Christ. Sistine chapel. Vatican. Spandrel beside the Flood. It is hardly possible to identify these biblical characters, but their identity, for Michelangelo, is less important than their appearance.

17 The Delphic Sibyl. Sistine chapel. Vatican. This sibyl, who is placed beneath the Drunkenness of Noah, is very close to the Virgin of the *Doni tondo*. We find in her a typical curving movement that passes through the body to the head, and emphasizes the eyes.

18 View of the right corner of the ceiling. Sistine chapel. Vatican. Near the entrance to the chapel, Here we get an idea of the complexity of Michelangelo's composition, with the great cornice, the Ignudi, the caryatid putti, the bronze-coloured nudes, the elegant ram's head motif, and the shell and acorn decoration.

19 Zachariah. Sistine chapel. Vatican. This prophet is placed above the entrance door of the chapel, and offers a typical example of the enlargement of the human form which Michelangelo practised as a follower of Masaccio. Raphael followed in the same tradition. Michelangelo was at pains to counteract what was to him the finicking approach of most painters of the second half of the fifteenth century.

20 View of the left corner of the ceiling. Sistine chapel. Vatican. Near the entrance. Here it is useful to observe the different proportions between the figures of prophets, large and small nudes, and David.

21 David and Goliath. Sistine chapel. Vatican. This subject is painted over the right hand corner by the entrance. The figure of the boy David stands out strongly against the tent, while the heavy body of the fallen giant gives a disturbing impression of being about to rise.

22 Judith and Holofernes. Sistine chapel. Vatican. Detail. Left corner spandrel, opposite no. 21. The figures here have the typical elegance, beauty and grace which are the ideal of sixteenth-century painters, and especially of Michelangelo.

23-24 The Fall of Adam, the Expulsion from Eden, and two Ignudi. Sistine chapel. Vatican. Michelangelo's primary preoccupations with group construction, plasticity and the beauty of the nude have totally dismissed any possibility of drama from the scene. In comparison with Masaccio's Adam and Eve, Michelangelo's figures are mere play actors. Each of the accompanying Ignudi seems to be physically present at the events depicted.

25 Ancestors of Christ. Sistine chapel. Vatican. This is the group in the spandrel alongside the Fall of Adam. Michelangelo conceives these groups sometimes as Holy Families, in attitudes that foreshadow their descendants. They are usually in shadow, where they seem to be almost asleep, or at least strangely apathetic.

26 Bronze-coloured nude and caryatid putti. Sistine chapel. Vatican. Here we have two of Michelangelo's most individual decorative motifs put together. The two putti are painted to look like marble, the nude to look like bronze. The bronze nudes vary in their attitudes, to convey indolence or to suggest unbridled lust.

27 Ancestors of Christ and bronze-coloured nudes. Sistine chapel. Vatican. The whiteness of the cornices, the caryatid putti, and the ram's head decoration, stand out strongly against the immaterial, shadowy atmosphere that surrounds the ancestors of Christ, and contrasts interestingly with the bronze nudes in their deep purple background.

28 Creation of Eve. Sistine chapel. Vatican. There seems to be something deliberate about the contrast between the extreme beauty of Adam, and the rather clumsy figure of Eve. One almost has the impression that the Creator has performed this last act of creation in a moment of tiredness and ill humour. The figure of the creator, with its rather curious fixity is derived from Michelangelo's early studies of Masaccio.

29 Sistine chapel ceiling. Vatican. The area between the Creation of Eve, and the Separation of Light from Darkness. Here we can get an idea of the variety in character and scale between the different figures, who all manage somehow to fit into a gigantic design. This is a new approach, and quite 'against the rules' as Vasari would have said. It ignores the scientific preoccupations of the fifteenth century, the geometrical perspective of Piero della Francesca, and the theories of Alberti. But as Michelangelo said, he measured with his eye, not with his hands.

30 Ignudo and medallion. Sistine chapel. Vatican. These are adjacent to the Creation of Eve, who kneels before God the Father with her hands joined. David repeats her gesture, kneeling before Nathan who has come to tell him of the imminent punishment for his misdeeds (II Samuel, XII). The plump Ignudo projects into both compositions, cleverly relating them.

31 Destruction of the Tribe of Ahab. Sistine chapel. Vatican. Medallion near the Creation of Eve. In this typical piece of sixteenth-century composition, the figures move with such ease and agility that they flow into a single compact unit. Such unstudied ease of movement was one of the great ideals of the period, not only in art but in social behaviour as well.

32 Ignudo and medallion. Sistine chapel. Vatican. These naked bodies in movement, alongside the Creation of Eve, with the accompanying architectural structure, are part of a highly artificial and unnatural conception of painting. None the less it was totally original, and it would dominate a whole century.

33 Sistine chapel ceiling. Vatican. This detail shows a bronze nude, two caryatid putti, and naked angels holding books, who are presumably the inspiration of the Cumaean sibyl to the right of them.

34 Ezekiel. Sistine chapel. Vatican. This prophet is on the same level as the Creation of Eve. It will be noticed that Michelangelo's colours do not blend, and for this reason they keep their metallic, polished look. Their only darkening is the *chiaroscuro*; they are often accentuated by use of iridescent colours.

35 Bronze-coloured nude. Sistine chapel. Vatican. This particular nude is on the same level as the Creation of Adam. A positively Satanic quality is achieved by the dark gold colouring of the figure, against its shadowy purple background.

36 Creation of Adam. Detail and Ignudo. Sistine chapel. Vatican. These two figures, although they belong to two distinct compositions, are beautifully related to each other. It is this relationship, linking each subject to the next one, that creates the unity of the ceiling.

37 Creation of Adam. Detail. Sistine chapel. Vatican. The gigantic figure of God the Father throws himself forward, with a movement of tremendous power and majesty. The flowing folds of his cloak shelter a group of angels.

38 Creation of Adam. Detail. Sistine chapel. Vatican. The angels surround the left hand of God the Fater, creating the effect of a setting round a holy relic. It is an extremely large and powerful hand, in a studied pose of relaxation that gives it an unnatural, feminine elegance.

39 Ancestors of Christ. Sistine chapel. Vatican. This is the group in the spandrel on the level of the Creation of Adam. It has something of the melancholy that Dürer was to convey a few years later in his famous engraving.

40 The Creation of the Waters. Sistine chapel. Vatican. The left hand of God the Father was repainted by Arnoldi in the sixteenth century. The maximum of light and energy, it will be noticed, are concentrated on the middle of the ceiling. The Ignudi at the corners are, at this point, extremely varied.

41 Ignudo. Sistine chapel. Vatican. Between the Creation of the Water, and the Creation of the Sun and Moon. The heroic figure is

possibly the one most representative of Michelangelo's ideal of masculine physical beauty. It is the type which was to become all too soon a commonplace of academism.

42 Persian sibyl. Detail. Sistine chapel. Vatican. This sibyl is shown as an old woman verging on the grotesque, but her figure is modelled with a wonderful feeling for elegant and continuous movement, finishing off in her averted profile.

43 Ignudo. Sistine chapel. Vatican. Between the Creation of the Water, and the Creation of the Sun and Moon. This figure, like its companion in *pl. 41*, has the look of someone overcome by a terrifying vision.

44 Daniel. Sistine chapel. Vatican. There is an interesting play of shadow in this figure, coming down from the hair, over the shoulder and left arm with its drapery, and finishing up with the rather unexpected boy's head.

45 Caryatid putti and bronze-coloured nude. Sistine chapel. Vatican. This detail of Michelangelo's 'inventions and caprices' comes between Daniel and the Creation of the Sun and Moon. The languid bronze nude, scratching his ear, has something traditionally diabolical about him despite his mannered elegance.

46 Creation of the Sun and Moon. Detail. Sistine chapel. Vatican. There is something particularly impressive in the angel protecting his eyes the light of the sun. The arm casts a shadow that gives a blind look to the eyes, emphasizing the strained expression which foreshortening gives.

47 Creation of the Plants. Sistine chapel. Vatican. There is something very concrete and convincing in these paintings of forms that Michelangelo has very carefully studied. The Mannerist tradition as practised by Bronzino, Daniele da Volterra, and Pellegrino Tibaldi, was to achieve almost surrealistic effects by following his example.

48 Two Ignudi. Sistine chapel. Vatican. These two occur between the first two episodes of the Creation, and they furnish yet another example of how Michelangelo can harmonize figures of differing proportion. We can see how he judged visually, as Vasari says, 'only seeking a harmony of grace among all the figures he put together'.

49 The Separation of Light from Darkness, the prophet Jonah, etc. Sistine chapel. Vatican. This area was the very last to be painted, and here we find that Michelangelo's passion for the body in movement has become a positive obsession. It is easy to understand why he wanted to write a treatise on the subject, directed against Dürer, whose forms he considered 'as stiff as posts' (Condivi).

50 Ancestors of Christ and bronze-coloured nudes. Sistine chapel. Vatican. A remarkable piece of decoration, alongside the Creation of the Plants. This Holy Family is one of the most hieratic of the whole series. The figures in it are smaller than the bronze nudes above them, and these latter, with their exhibitionistic pose, create a mocking contrast.

51 Jeremiah. Detail. Sistine chapel. Vatican. The expression, and the pose of this prophet make him a positive monument to grief. The gesture with the hand is unforgettable. This Jeremiah is infinitely removed from any similar treatment done in the fifteenth century.

52 Caryatid putti. Sistine chapel. Vatican. This pair is placed to the right of the Libyan sibyl. The sixteenth century was to become very attached to such caprices and 'bizarreries'.

53 The Separation of Light from Darkness, and an Ignudo. Sistine chapel. Vatican. This nude reminds us to some extent of the so-called *Dying Slave* in the Louvre, on account of his exhausted appearance. His scale is smaller than that of God the Father, but the movement of his body links him to the more powerful movement of the larger figure.

54 The Separation of Light from Darkness. Detail. Sistine chapel. Vatican. Between the pincer movement of these colossal arms, the head, which is an amazing piece of foreshortening, really does suggest something seen in a vision.

55 View of the left corner of the ceiling. Over the altar. Sistine chapel. Vatican. Compared with the views in *pl. 18* and *20*, this area presents a more violent and frenzied sense of movement.

56 Ignudo. Sistine chapel. Vatican. The freedom with which Michelangelo treats the body, and the endless variety of attitudes which he can devise, give an overwhelming sense of sheer physical being to these nudes. This one is adjacent to the Separation of Light from Darkness.

57 The punishment of Haman, from the story of Esther. Sistine chapel. Vatican. On the right, King Ahasuerus is shown in bed, having read to him the chronicles in which it appears that Mordecai the Jew has saved his life. He orders Haman to summon Mordecai who sits at the palace gate, so that he may be honoured. On the left we are shown the banquet which Esther gives for Ahasuerus and Haman, during which she reveals to the king, her husband, Haman's plot to destroy the Jewish people. In the centre, Haman is being crucified on a tree trunk (not hanged, as the biblical account relates). Michelangelo evidently made this change because it gave him a more dramatic foreshortening.

58 Jonah. Sistine chapel. Vatican. The wildly ecstatic figure of this prophet seemed to Michelangelo's contemporaries the most awe-inspiring of all the subjects on the ceiling. The difficulties involved appalled everyone. On account of the curvature of the ceiling at this point, the forward thrust of the legs occurs where the wall is most distant from us. Then, as the wall curves outwards, the figure of the prophet is made to lean back, abruptly foreshortened.

59-62 The Brazen Serpent. Sistine chapel. Vatican. As a punishment on the Jews who had spoken against God and Moses, fiery serpents are sent among the people, bringing plague and death. When they have repented, God tells them to make a brazen serpent, and set it up so that those who have been bitten by the snakes may look on it and be healed. Clearly the *Laocoön* was a source of inspiration for this work; Michelangelo achieves the absolute maximum of movement in telling this story. *Pl. 60* shows the same deforming kind of foreshortening that Primaticcio uses in some of his drawings. Here it makes a corpse look as if it were still writhing in delirium. Michelangelo's restless imagination has conjured up such a tense despair, that we might think ourselves here in some ante-chamber of hell.

63 Putto bearing the inscription of the Libyan Sibyl. Sistine chapel. Vatican. The lunettes containing the ancestors of Christ were the last part of the ceiling to be painted. The spaces between the lunettes are occupied by putti bearing the inscriptions relating to the sibyls and prophets. These putti are among the most soft and shadowed figures that Michelangelo ever produced.

64 Ancestors of Christ. Detail of a lunette. Sistine chapel. Vatican. A figure verging on the grotesque, conceived as a sort of wizard with a staff and a long white beard.

65 Putto bearing the inscription of Daniel. Sistine chapel. Vatican. This rather heavy-looking figure almost disappears into the shadowy atmosphere that dominates at this level of the ceiling.

66 Ancestors of Christ. Detail of a lunette. Sistine chapel. Vatican. Melancholy is conveyed by the introspective attitude, and the shadow seems particularly significant here. To the left there is an extremely beautiful spiral effect, to be developed in due course by the Mannerists.

67-68 Ancestors of Christ. Lunette. Sistine chapel. Vatican. To achieve his Jewish effects, Michelangelo sometimes verges on carica-ture, as we notice here in the oriental trousers and the cloak shot with improbable red and green. The woman is a beautiful reminder of the traditional group representing charity. The impressive frame of the tablet bearing three names is already a fine piece of Mannerism.

69 Ancestors of Christ. Detail of a lunette. Sistine chapel. Vatican. This magnificent figure of a woman, emerging from the shadows as if by magic, has the soft *chiaroscuro* effect that would appeal to Correggio.

70 Resurrection of Christ. Pencil drawing in the British Museum, no. 1860-6-16-133.

71-76 Last Judgment. Sistine chapel. Vatican. See p. 22.

77-78 Conversion of Saint Paul and Crucifixion of Saint Peter. Frescoes in the Pauline chapel, Vatican.

79 Pietà. Pencil drawing in the British Museum, no. 1896-7-10-1. In his old age Michelangelo drew a large number of religious subjects. This remarkable group may be a design for one of his later marble sculptures of the Pietà.

80 Crucifixion. Pencil drawing in the British Museum. No. 1895-9-15-509. See p. 27.

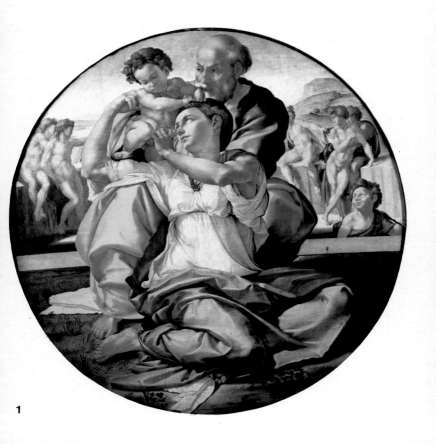

1

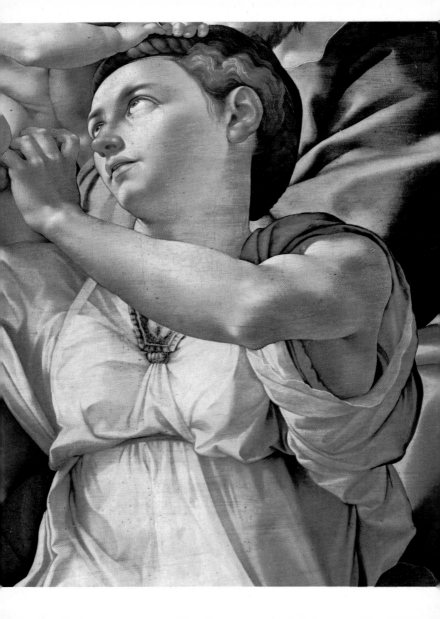

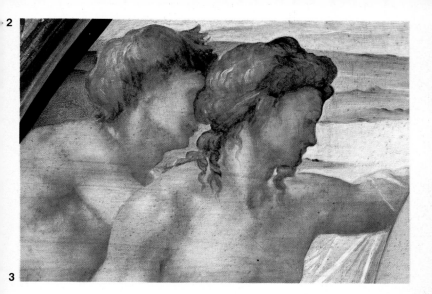

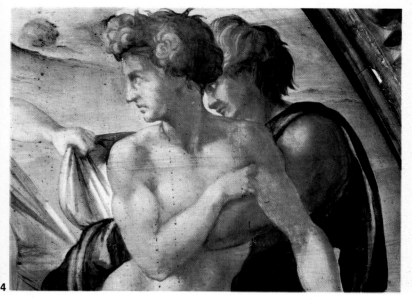

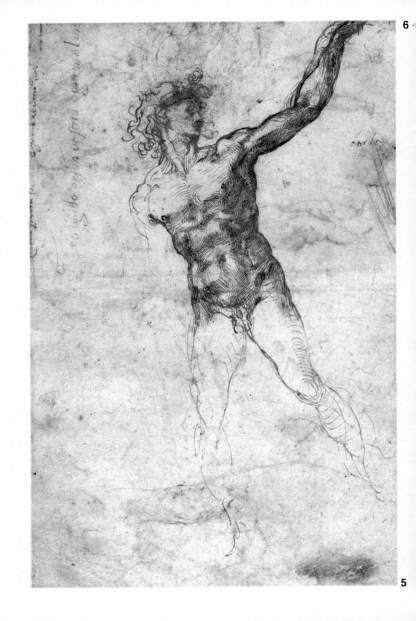

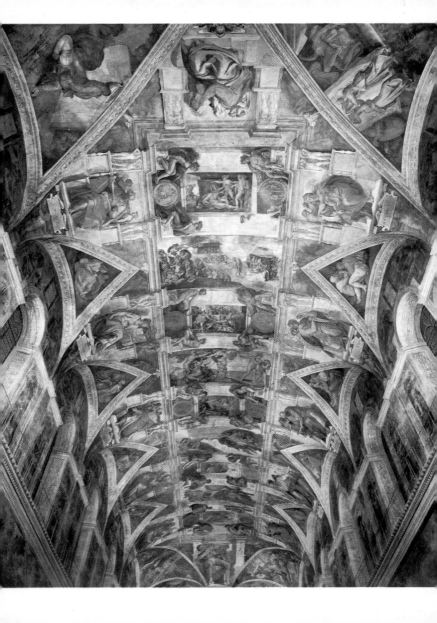

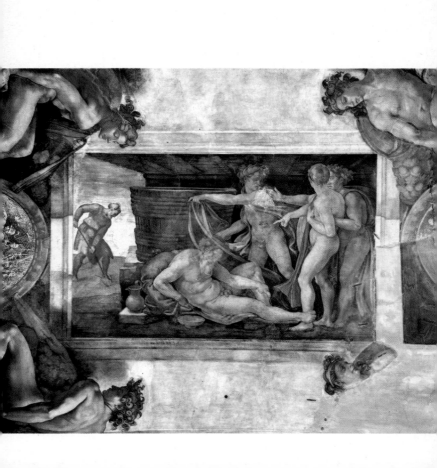

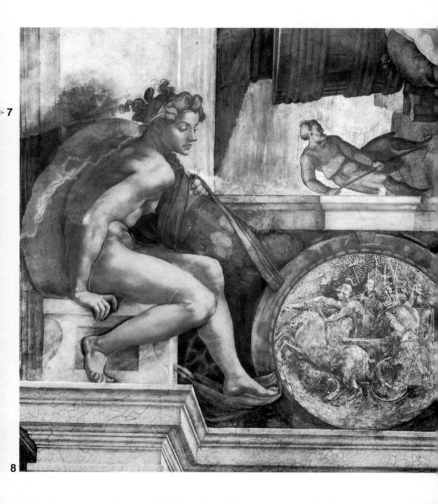

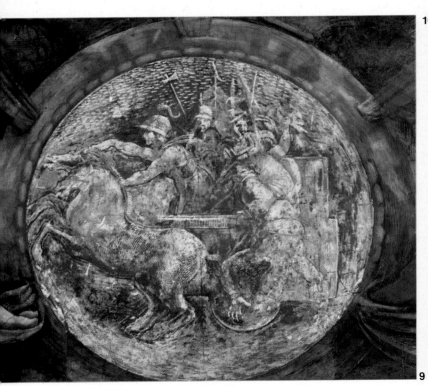

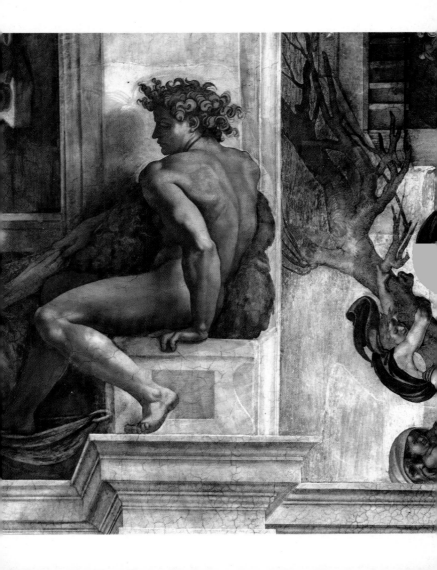

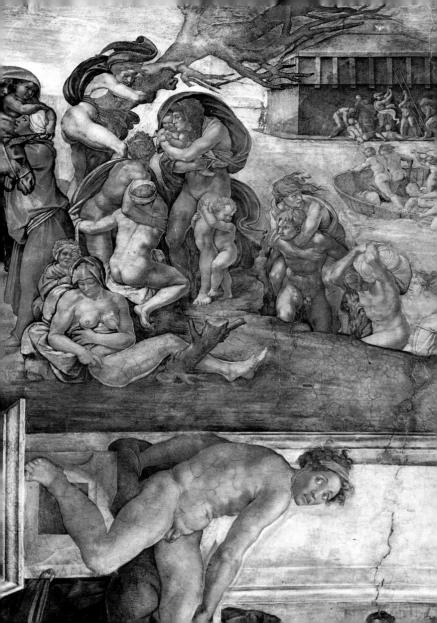

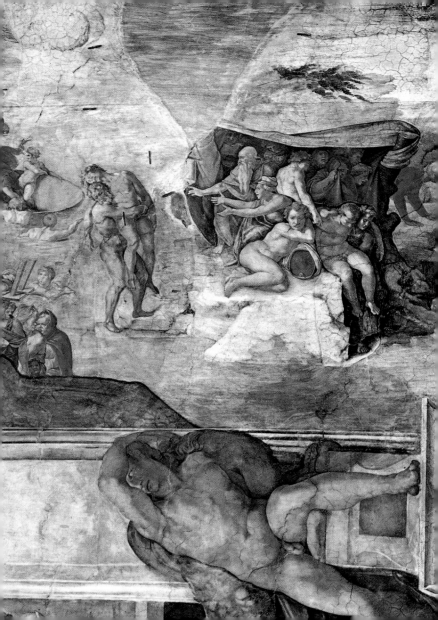

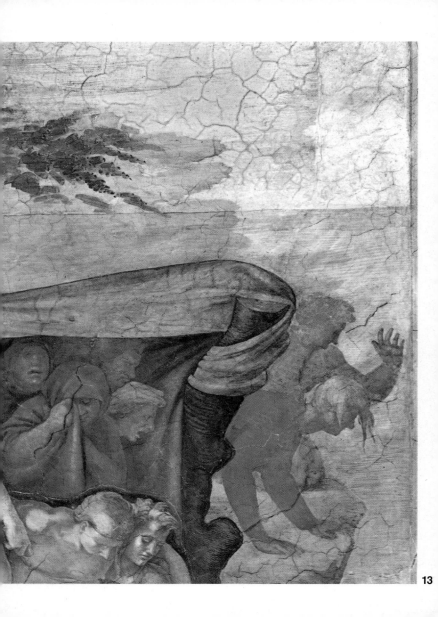

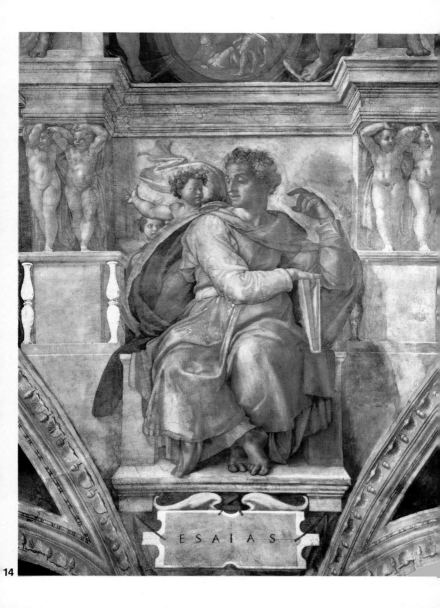

ESAIAS

14

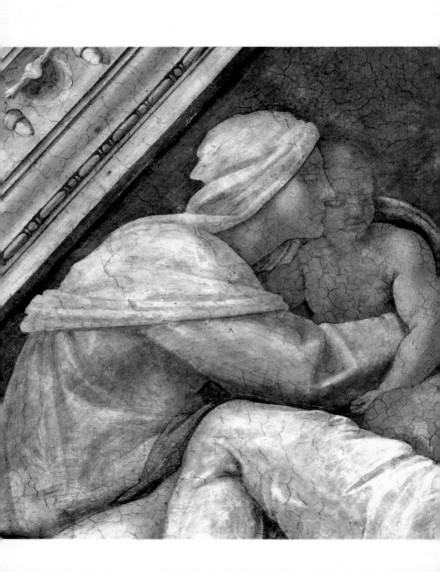

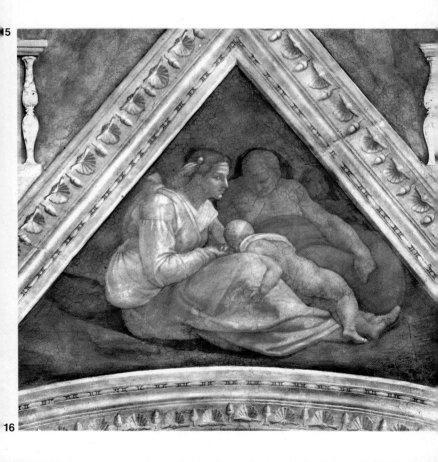

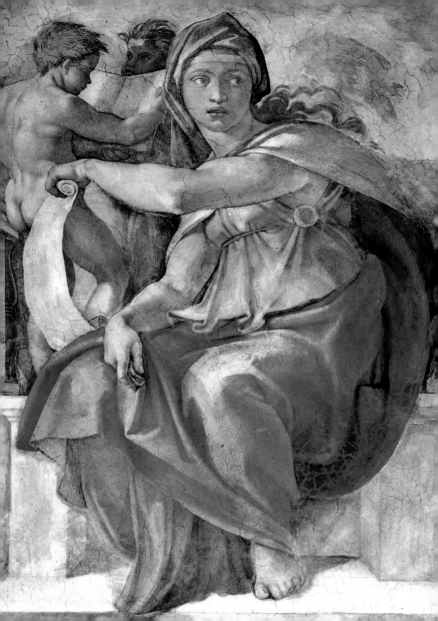

7

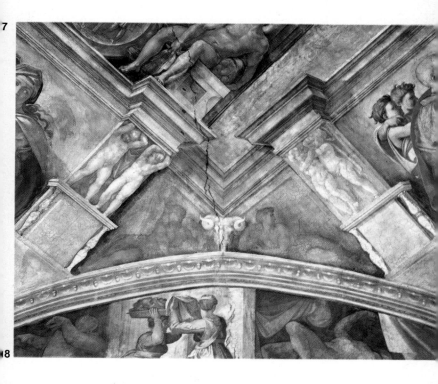

8

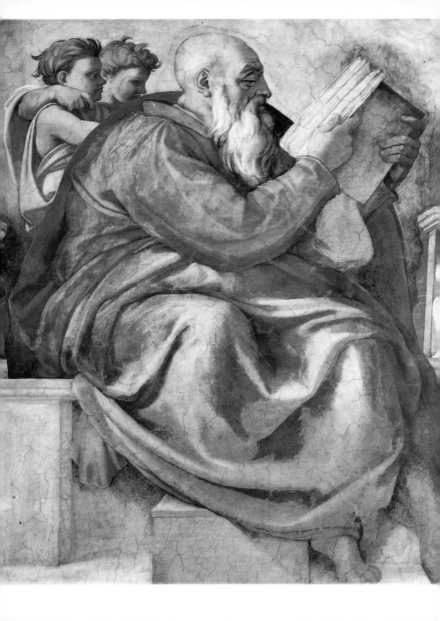

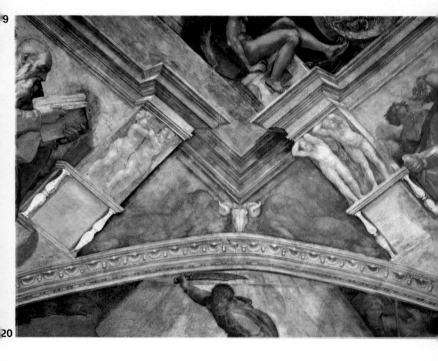

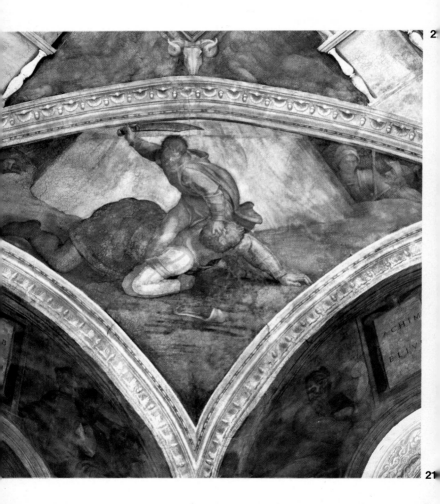

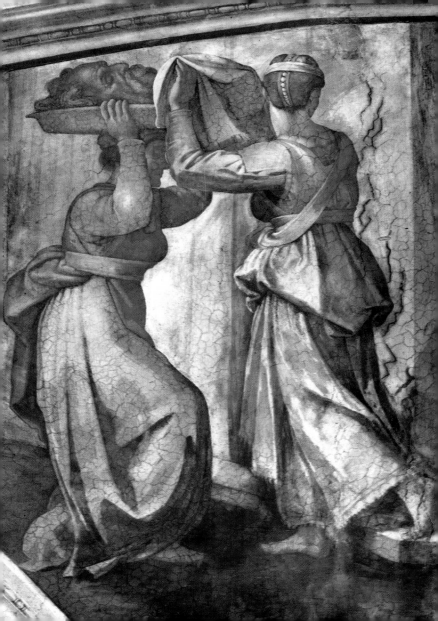

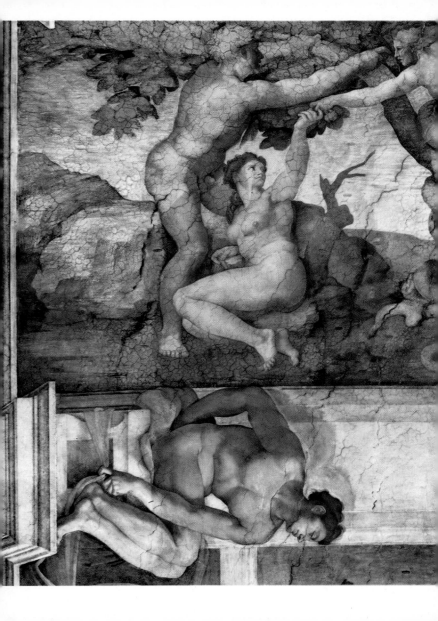

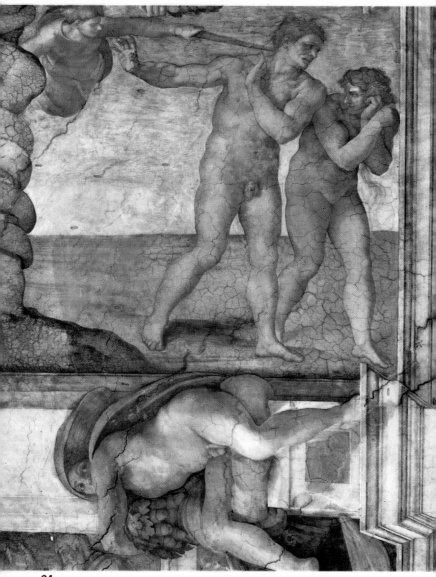

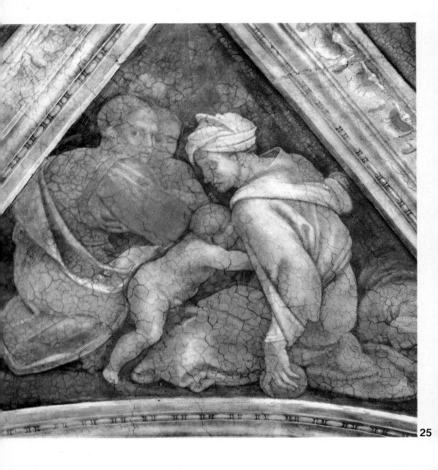

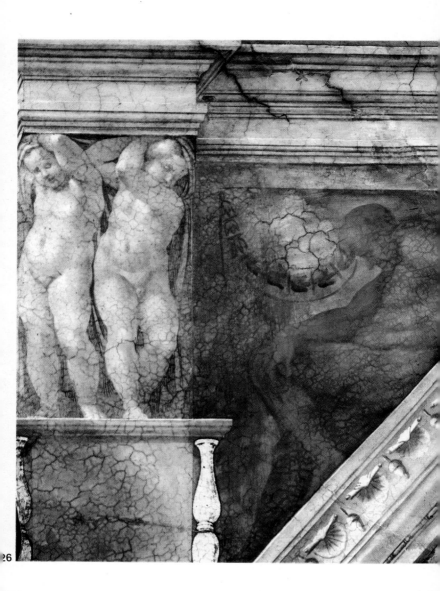

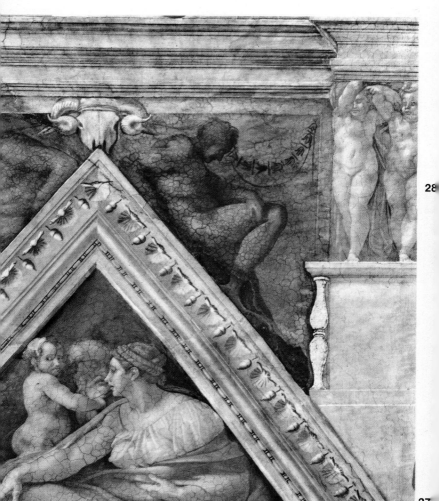

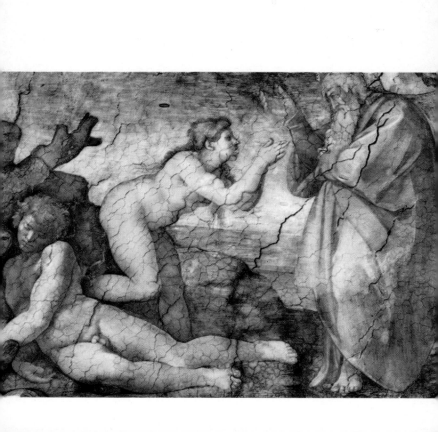

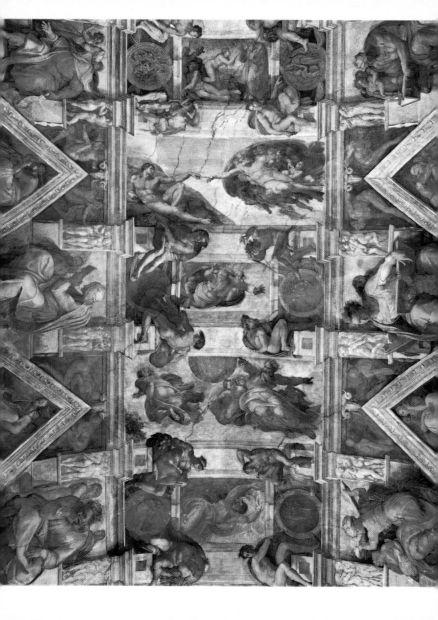

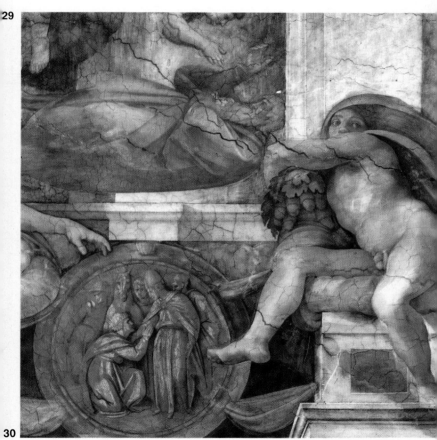

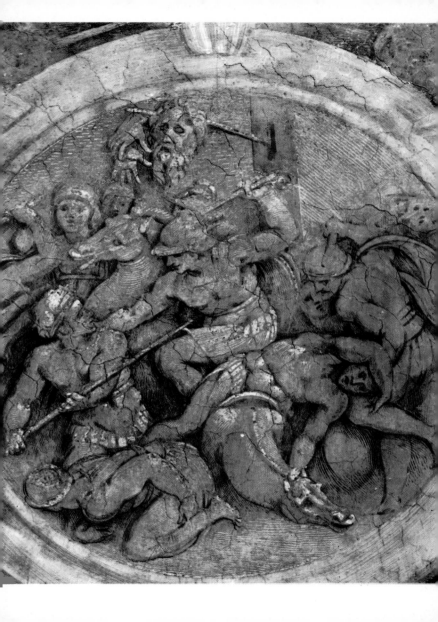

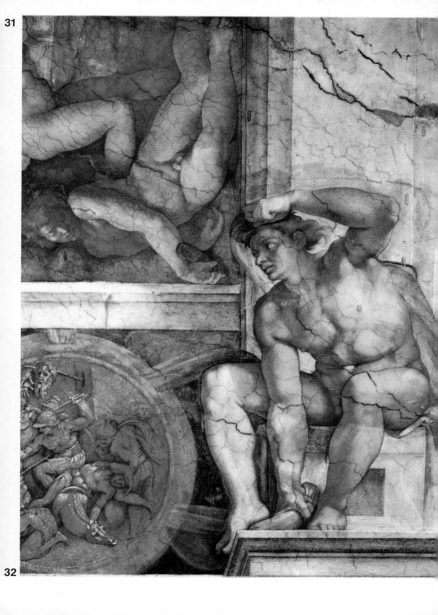

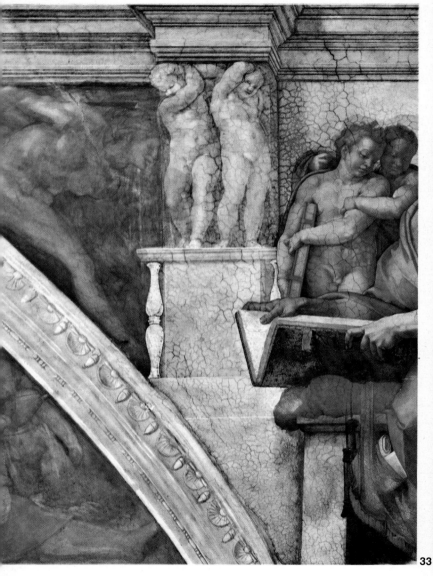

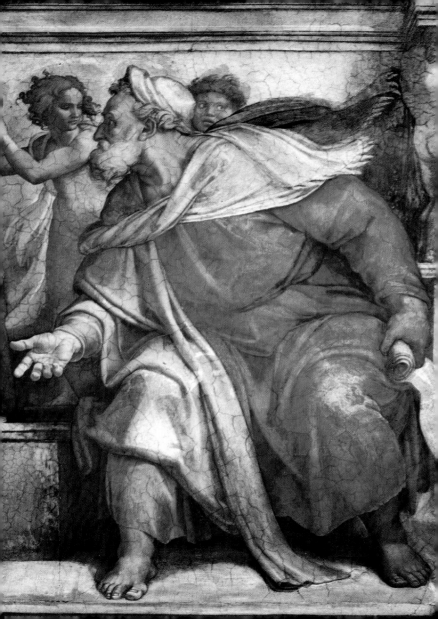

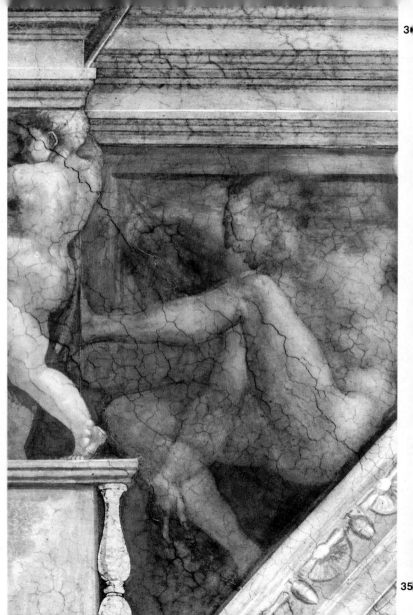

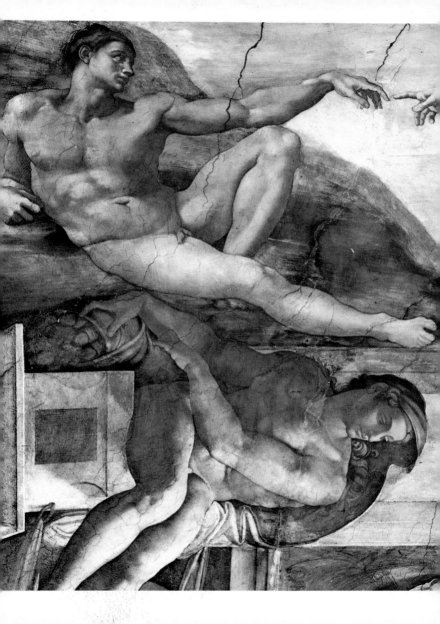

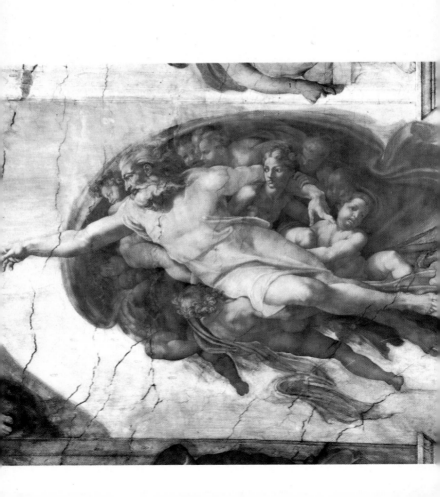

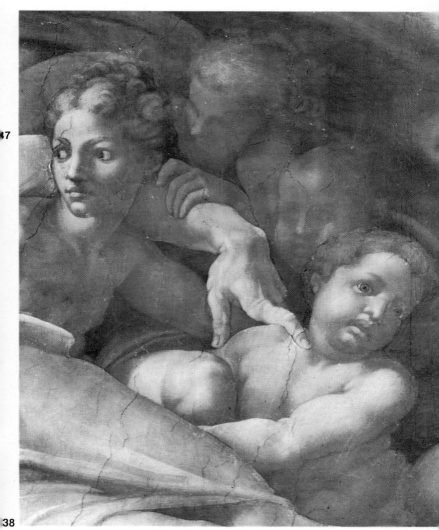

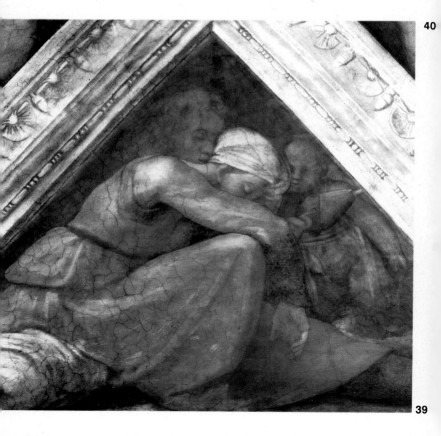

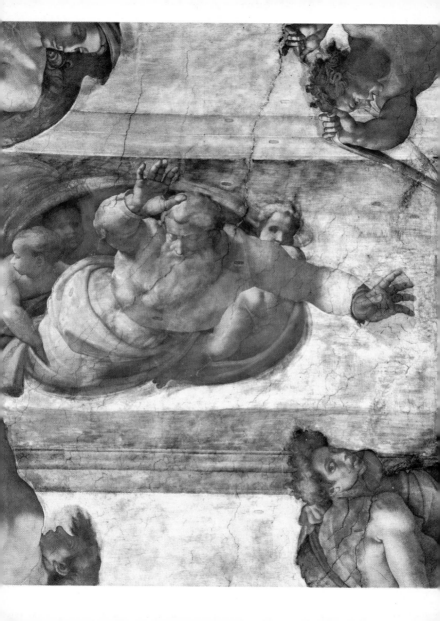

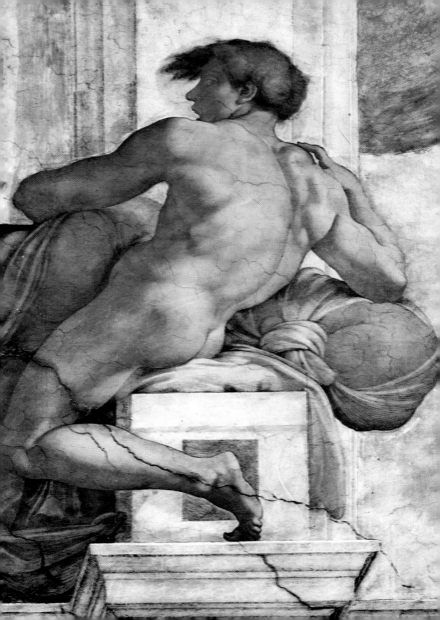

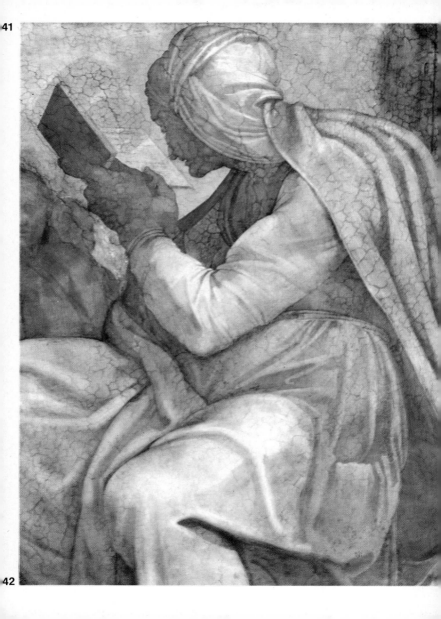

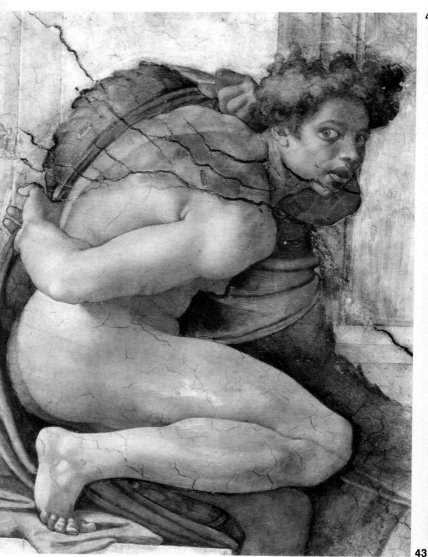

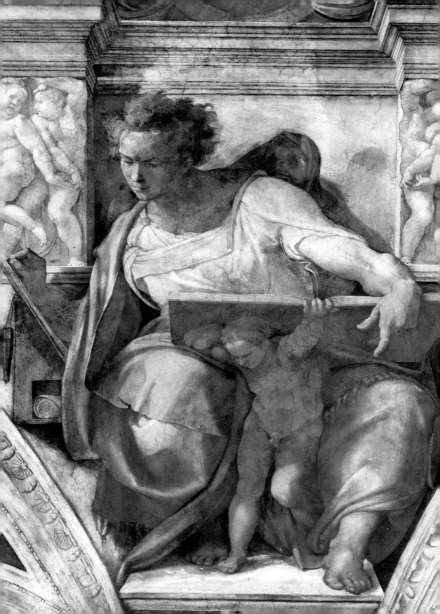

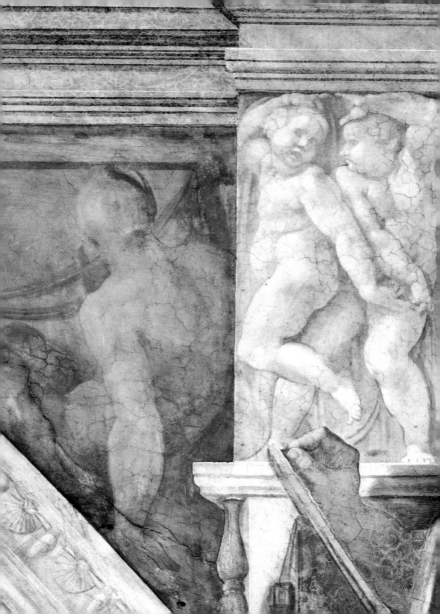

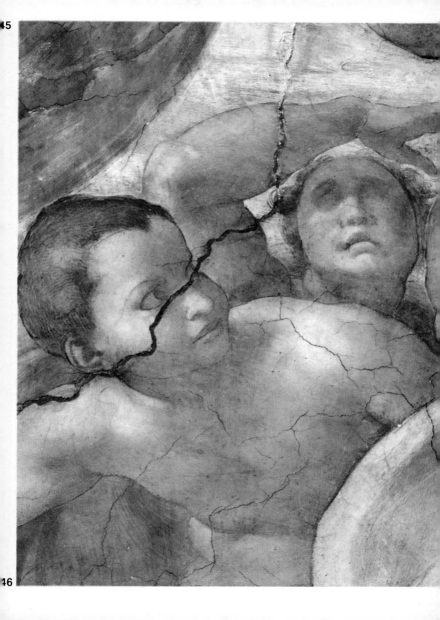

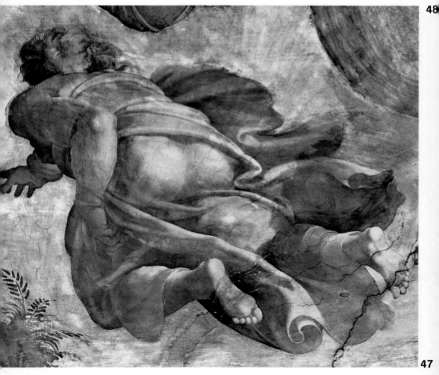

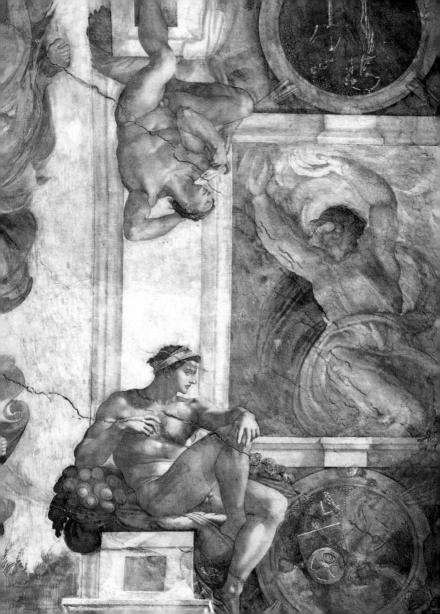

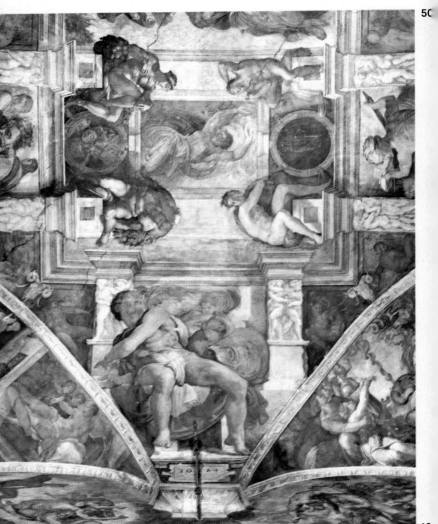

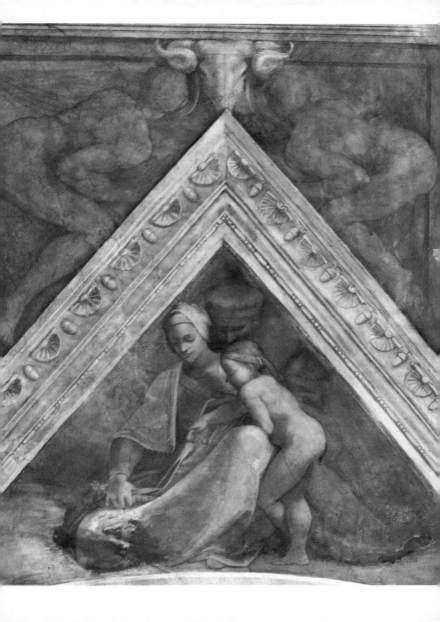

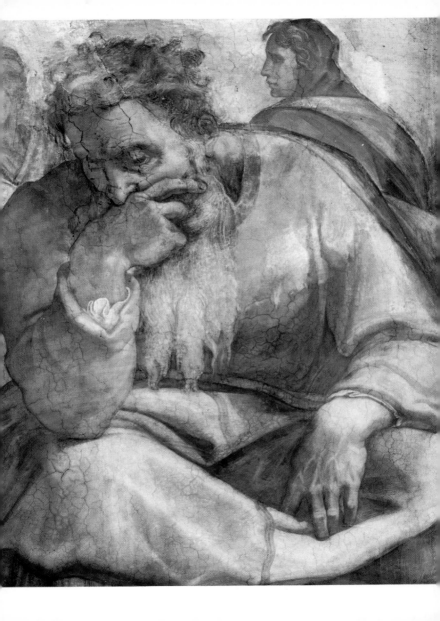

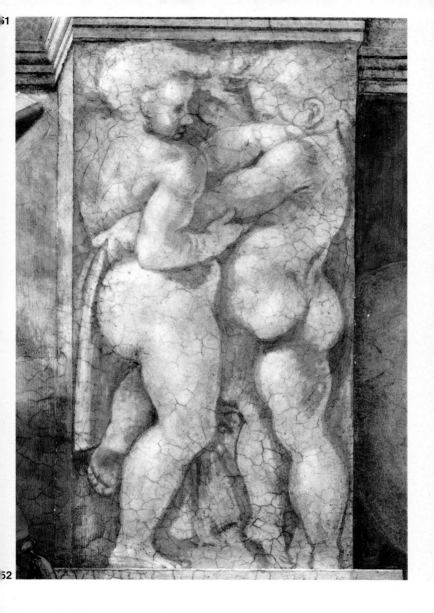

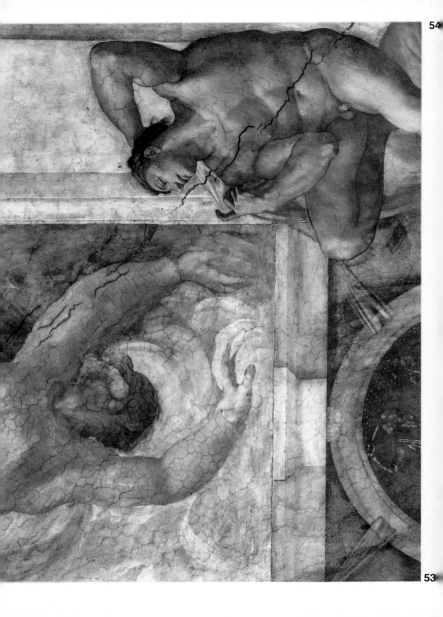

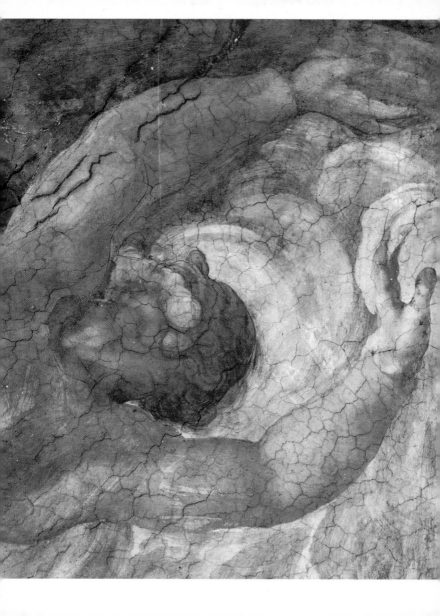

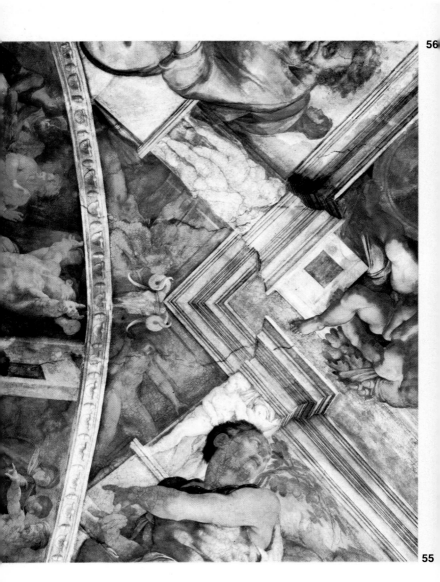

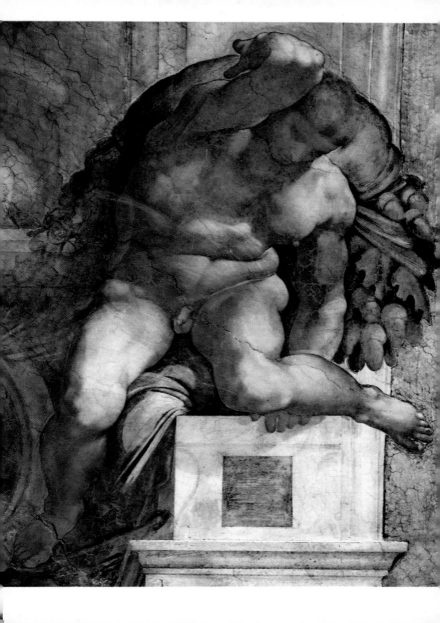

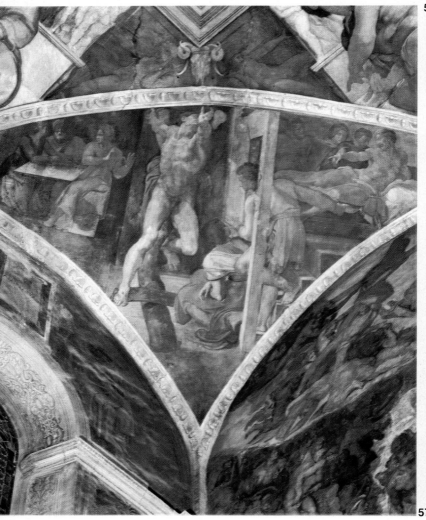

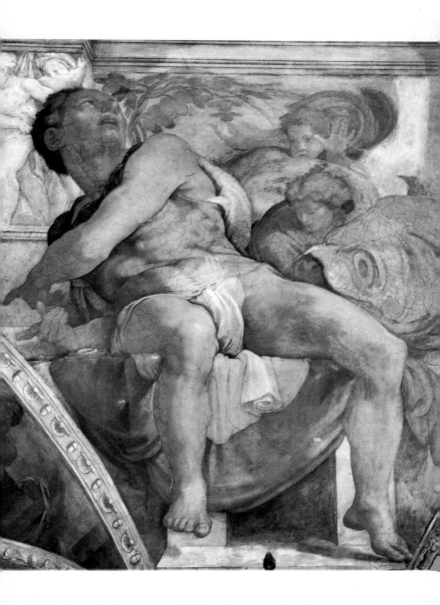

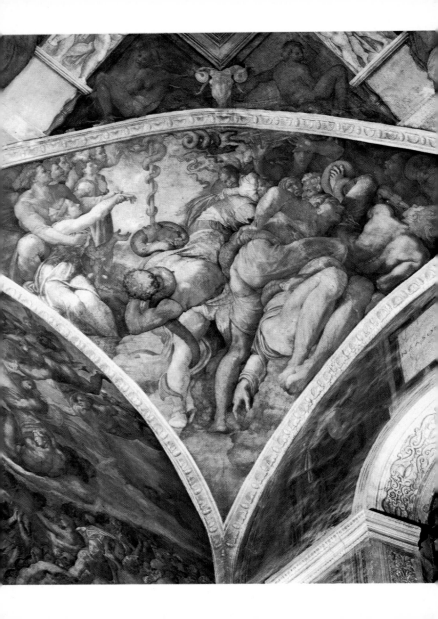

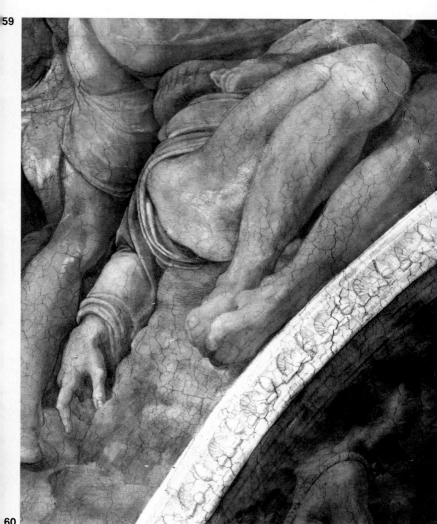

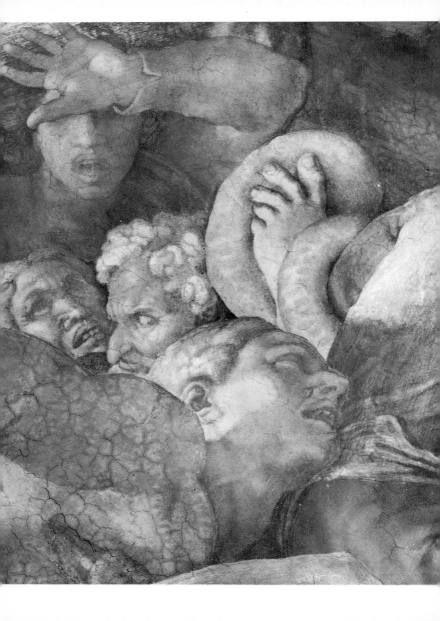

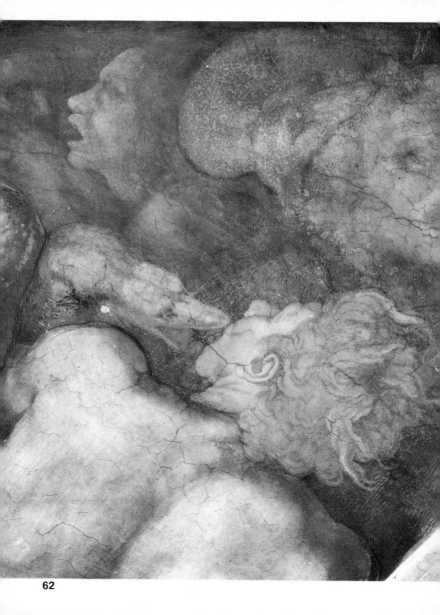

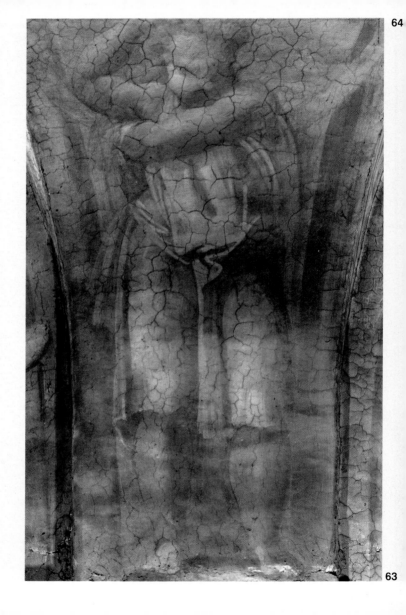

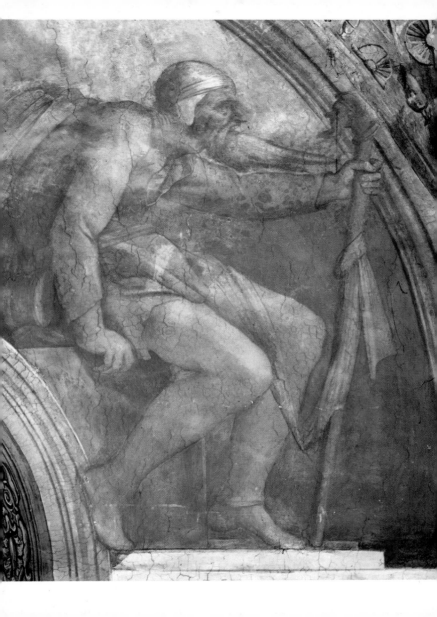

DANIEL

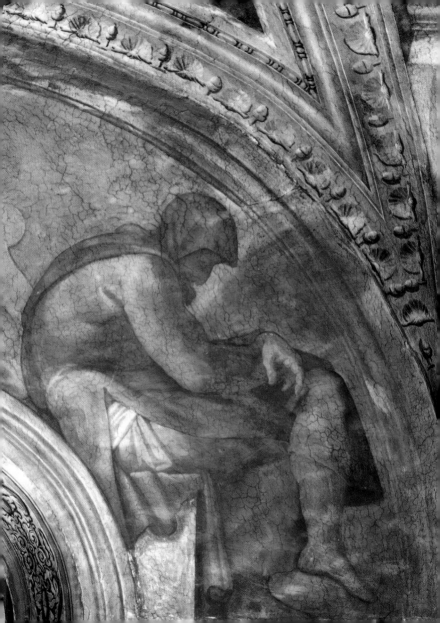

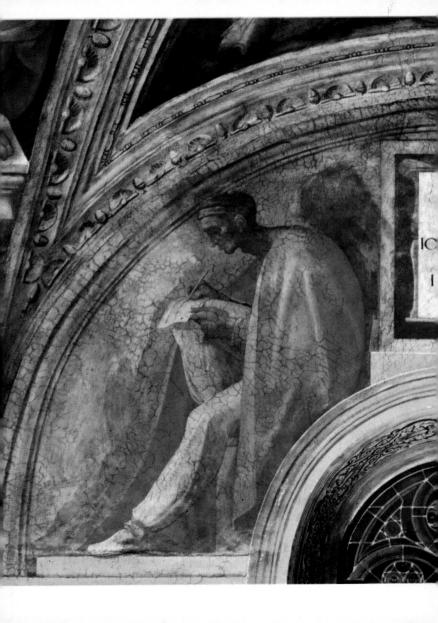

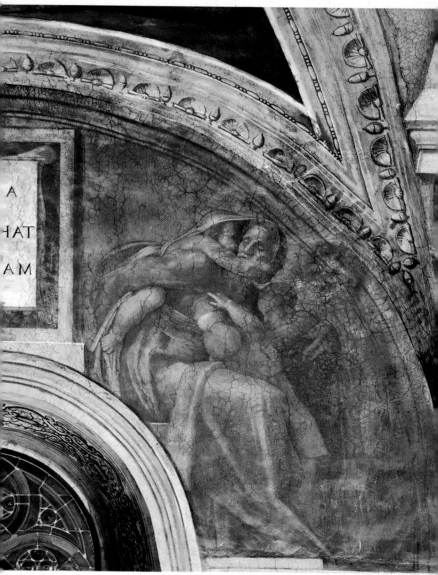

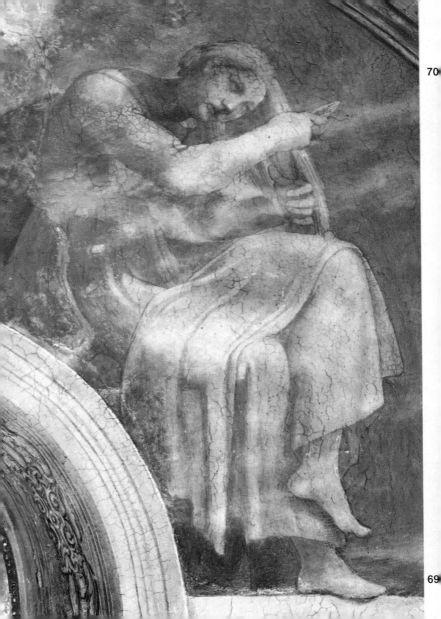

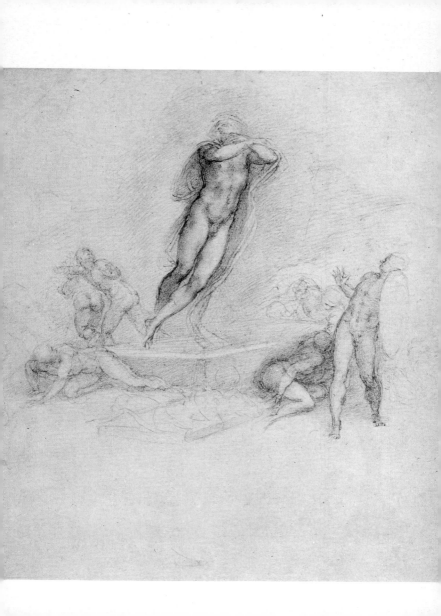

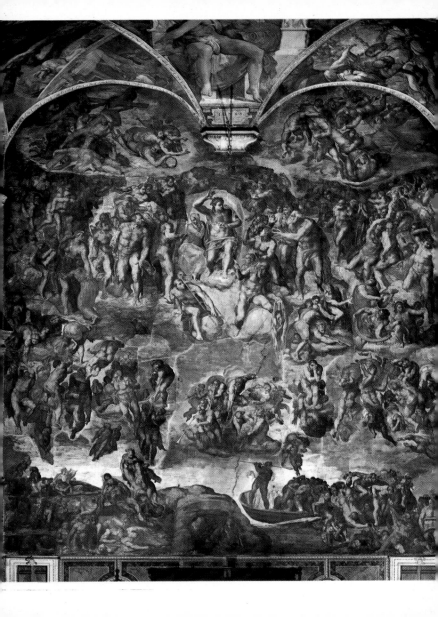

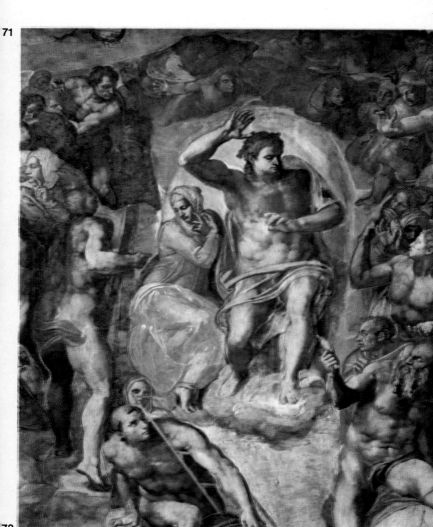

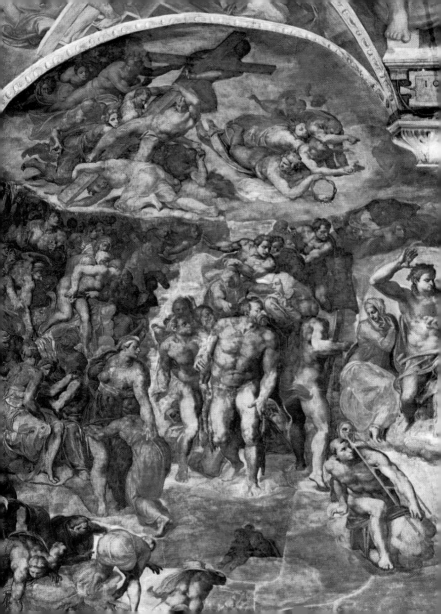

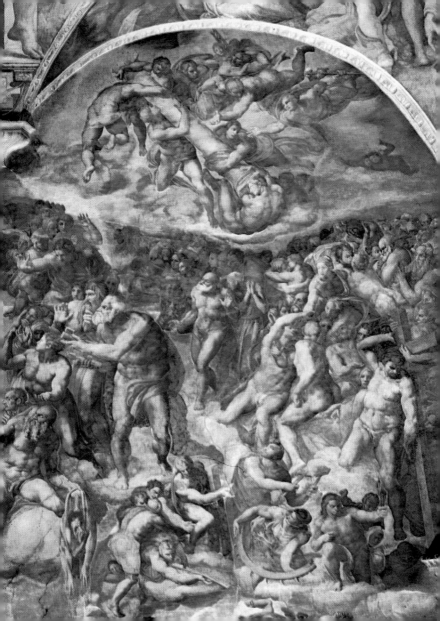

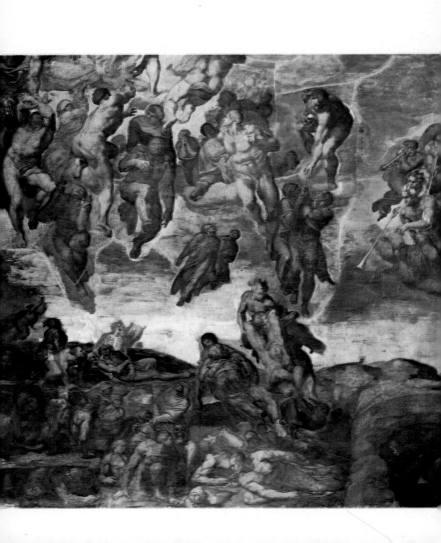

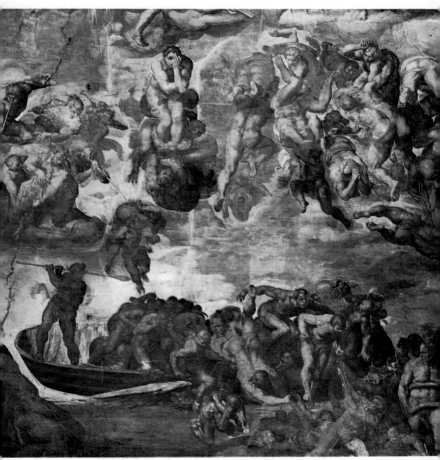

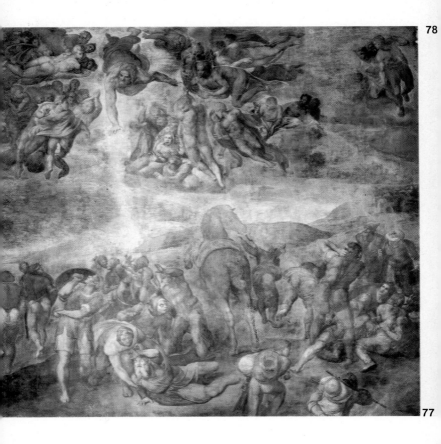

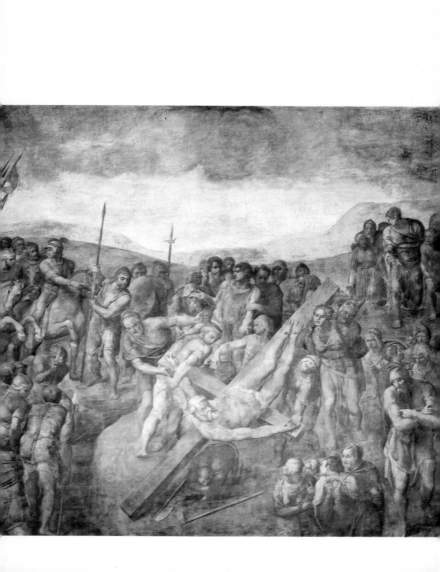

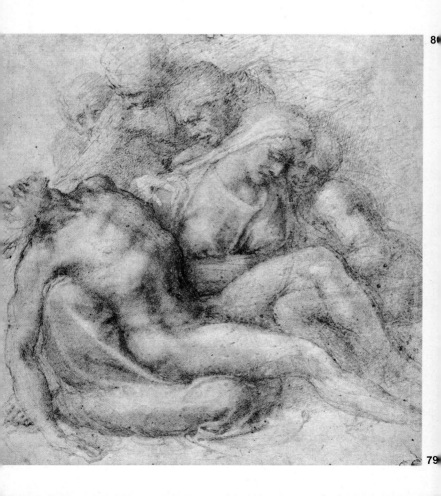

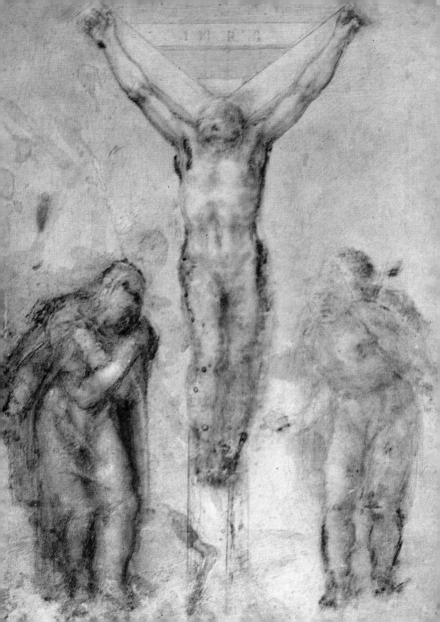

PENGUIN BOOKS

BARCHESTER TOWERS

Anthony Trollope was born in London in 1815 and died in 1882. His father was a barrister who went bankrupt and the family was maintained by his mother, Frances, who was a well-known writer. He received little education and his childhood generally seems to have been an unhappy one.

Happily established in a successful career in the Post Office (from which he retired in 1867), Trollope's first novel was published in 1847. He went on to write over forty novels as well as short stories, and enjoyed considerable acclaim as a novelist during his lifetime. The idea for *The Warden* (1855), the first of his novels to achieve success, was conceived while he wandered around Salisbury Cathedral one midsummer evening. It was succeeded by other 'Barsetshire' novels employing the same characters including Archdeacon Grantly, the worldly cleric, the immortal Mrs Proudie and the saintly warden, among others. These novels are *Barchester Towers* (1857), *Doctor Thorne* (1858), *Framley Parsonage* (1861), *The Small House at Allington* (1864), and *The Last Chronicle of Barset* (1867). This series is regarded by many as Trollope's masterpiece in which he demonstrates his imaginative grasp of the great preoccupation of eighteenth and nineteenth century English novels – property. Almost equally popular were the six brilliant Palliser novels comprising *Can You Forgive Her?* (1864), *Phineas Finn* (1869), *The Eustace Diamonds* (1873), *Phineas Redux* (1874), *The Prime Minister* (1876) and *The Duke's Children* (1880).

Trollope has been acclaimed as a supreme portraitist of the professional and landed classes of mid Victorian England. His early novels depict, with irony and wit, the comfortable world of the English gentry, contrasting the apparent stability of rural life with the harsh, disturbing rhythms of London. In his later work, Trollope's rural order has given way to the values of industrial society and his tone is generally gloomier and more pessimistic.

Anthony Trollope

BARCHESTER TOWERS

Text established by Robin Gilmour

PENGUIN BOOKS

Penguin Books Ltd, Harmondsworth, Middlesex, England
Penguin Books, 625 Madison Avenue, New York, New York 10022, U.S.A.
Penguin Books Australia Ltd, Ringwood, Victoria, Australia
Penguin Books Canada Ltd, 2801 John Street, Markham, Ontario, Canada L3R 1B4
Penguin Books (N.Z.) Ltd, 182–190 Wairau Road, Auckland 10, New Zealand

First published 1857
Published in Penguin Books 1982

Made and printed in Great Britain by
Richard Clay (The Chaucer Press) Ltd, Bungay, Suffolk
Filmset in Monophoto Photina by
Northumberland Press Ltd, Gateshead